DIARY OF A GENIUS

SALVADOR DALÍ

DIARY OF A GENIUS
Salvador Dalí
ISBN-13: 978-1-84068-684-5
Published 2023 by Deicide Press
Copyright © Éditions de la Table Ronde 1964
Translated from the French by Richard Howard
Notes by Michel Déon.
"The Art Of Salvador Dalí" copyright © J G Ballard (first published in 1974),
reproduced by permission of J G Ballard
All rights in the visual works of Salvador Dalí reserved by Fundación Gala-
Salvador Dalí, Figueras
The right of Salvador Dali to be identified as author of this work has been
asserted in accordance with Section 77 of the Copyright, Designs and Patents Act
1988
This edition copyright © Deicide Press 2022

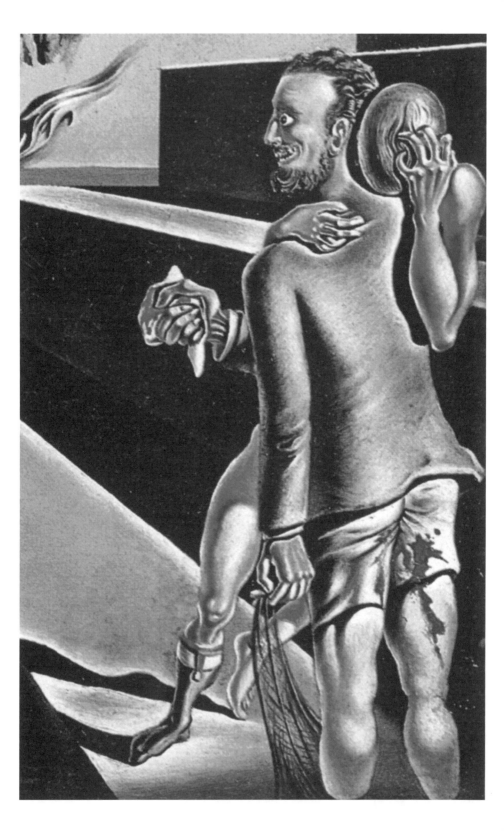

THE ART OF SALVADOR DALÍ
J G BALLARD

"The specialised sciences of our time are concentrating on the study of the three constants of life: the sexual instinct, the sentiment of death, and the anguish of space-time."

SALVADOR DALÍ, IN 'DALÍ';
HARRY N. ABRAMS INC., NEW YORK, 1968.

The uneasy marriage of reason and nightmare which has dominated the 20th century has given birth to an increasingly surreal world. More and more, we see that the events of our own times make sense in terms of surrealism rather than in any other view – whether the grim facts of the death-camps, Hiroshima and Viet Nam, or our far more ambiguous unease at organ transplant surgery and the extra-uterine foetus, the confusions of the media landscape with its emphasis on the glossy, lurid and bizarre, its hunger for the irrational and sensational. The art of Salvador Dalí, an extreme metaphor at a time when only the extreme will do, constitutes a body of prophecy about ourselves unequalled in accuracy since Freud's *Civilisation And Its Discontents*. Voyeurism, self-disgust, the infantile basis of our fears and longings, and our need to pursue our own psychopathologies as a game – these diseases of the psyche Dalí has diagnosed with dismaying accuracy. His paintings not only anticipate the psychic crisis which produced our glaucous paradise, but document the uncertain pleasures of living within it. The great twin leitmotifs of the 20th century – sex and paranoia – preside over his life, as over ours.

Painter, writer, engraver, illustrator, jeweller, personality – Dalí's polymath genius is on a par with Leonardo's. With Max Ernst and William Burroughs he forms a trinity of men of genius prepared to place their art at the total disposal of the unconscious. However, where Ernst and Burroughs transmit their reports at midnight from the dark causeways of our spinal columns, Dalí has chosen to face all the chimeras of our minds in the full glare of noon. Again, unlike Ernst and Burroughs, whose reclusive personalities merge into the shadows around them, Dalí's identity remains entirely his own. Don Quixote in a silk lounge suit, he rides eccentrically across a viscous and overlit desert, protected by nothing more than his furious moustaches.

"The quicksands of automatism and dreams vanish upon awakening. But the rocks of the imagination still remain."

SALVADOR DALÍ, IN 'THE WORLD OF SALVADOR DALÍ';
MACMILLAN, 1962.

For many people, it goes without saying, Dalí has always been far too much his own man. In recent years, after a long period in the wilderness, surrealism has enjoyed a sudden vogue, but to some extent Dalí still remains excluded – thanks, firstly, to the international press, which has always encouraged his exhibitionist antics, and secondly to the puritanical intelligentsia of northern Europe and America, for whom Dalí's subject matter, like the excrement he painted in *The Lugubrious Game*, reminds them far too much of all the psychic capitulations of their childhoods

"At the age of six I wanted to be a cook. At seven I wanted to be Napoleon. And my ambition has been growing steadily ever since."
SALVADOR DALÍ, IN 'THE WORLD OF SALVADOR DALÍ';
MACMILLAN, 1962.

Admittedly, Dalí's chosen public persona – part clown, part mad muezzin on his phallic tower crying out a hymn of gobbets of psychoanalysis and self-confession, part genius with all its even greater embarrassments – is not one that can be fitted into any handy category. Surprisingly, though, Dalí's background was conventional. He was born in Figueras, near Barcelona, on May 11, 1904, the second son of a well-to-do lawyer, and enjoyed a permissive and well-loved childhood populated with indulgent governesses, eccentric art masters, old beggar-women and the like. At art school he developed his precociously brilliant personality, and discovered psychoanalysis.

By this time, the late 1920's, surrealism was already an established art. Chirico, Duchamp and Max Ernst were its elder statesmen. Dalí, however, was the first Surrealist to accept completely the logic of the Freudian age, and to describe the extraordinary world of the 20th century psyche in terms of the commonplace vocabulary of everyday life – telephones, wrist-watches, fried eggs, cupboards, beaches. What distinguishes Dalí's work, above everything else, is the hallucinatory naturalism of his Renaissance style. For the most part the landscapes of Ernst, Tanguy and Magritte describe impossible or symbolic worlds – the events within them have 'occurred', but in a metaphorical sense. The events in Dalí's paintings are not far from our ordinary reality.

"After Freud it is the outer world, the world of physics, which will have to be eroticised and quantified."
SALVADOR DALÍ, IN 'THE WORLD OF SALVADOR DALÍ';
MACMILLAN, 1962

This reflects Dalí's total involvement in Freud's view of the unconscious as a narrative stage. Elements from the margins of one's mind – the gestures of minor domestic traffic, movements through doors, a glance across a balcony – become transformed into the materials of a bizarre and overlit drama. The Oedipal conflicts we have carried with us from childhood fuse with the polymorphic landscapes of the present to create a strange and ambiguous future. The contours of a woman's back, the significance of certain rectilinear

forms, marry with our memories and desires. The roles of everything are switched. Christopher Columbus comes ashore, having just discovered a young woman's buttocks. A childhood governess still dominates the foreshore of one's life, windows let into her body as in the walls of one's nursery. Later, in the mature Dalí, nuclear and fragmentary forms transcribe the postures of the Virgin, tachist explosions illuminate the cosmogony of the H-bomb, the images of atomic physics are recruited to represent a pietist icon of a Renaissance madonna.

Given the extraordinary familiarity of Dalí's paintings, it is surprising that so few people seem ever to have looked at them closely. If they remember them at all, it is in some kind of vague and uncomfortable way, which indicates that it is not only Oedipal and other unconscious symbols that frighten us, but any dislocation of our commonplace notions about reality. The latent significance of curvilinear as opposed to rectilinear forms, of soft as opposed to hard geometries, are topics that disturb us as much as any memory of a paternal ogre. Applying Freud's principle, we can see that reason safely rationalises reality for us. Dalí pulls the fuses out of this comfortable system. To describe the landscapes of the 20th century, he uses its own techniques, its deliberate neuroticism and self-indulgence. Behind these, however, is an eye as sharp as a surgeon's.

In addition, Dalí's technique of photographic realism, and the particular cinematic style he adopted, involve the spectator too closely for his own comfort. Where Ernst, Magritte and Tanguy relied very much on a traditional narrative space, presenting the subject matter frontally and with a generalised time structure, Dalí represents his paintings as if each was a single frame from a movie. Filled with a disquieting light that is more electric than solar, his paintings are like stills from some elegant but unsentimental newsreel filmed inside our heads. Taken together, Dalí's work shows a remarkable degree of homogeneity, an unfaltering freshness and power of imagination. Above all, Dalí is faithful to his obsessions, holding nothing back, even an occasional slickness or absurdity. Of Dalí more than any other painter it can be said that the whole man is present in his art. This honesty marks him out as a true modern. Tracing the development of his paintings, we see that they fall into a number of related groups:

(1) The classic Freudian phase. The trauma of birth, as in *The Lugubrious Game* and *The Persistence Of Memory*, the irreconcilable melancholy of the exposed embryo. This world of fused beaches and overheated light is that perceived by the isolated child. The nervous surfaces are wounds on the cerebral cortex. The people who populate this earliest period of Dalí's surrealism, the Oedipal figures and marooned lovers, are those perceived through the glass of childhood and adolescence. The obsessions are the flaccid penis, excrement, anxiety, the timeless place, the threatening posture, the hallucinatory over-reality of chairs and tables, the disquieting geometry of rooms and stairways.

(2) The metamorphic phase. A poly-perverse period, a free-for-all of image and identity. From this period, which began during the 1930's, come Dalí's obsessions with Hitler (the milky breasts of the Fuehrer compressed by his leather belt) and with Lenin, who is shown with buttock elongated like an immense sexual salami. Also most of the nightmare paintings, such as *Autumn Cannibalism*, which anticipate not only World War II, but the metamorphic horrors of heart surgery and organ transplants, the interchangeability and dissolving identities of our own bodies.

(3) The religious phase. By the mid-1940's, after such paintings as *Geopoliticus Child Watching The Birth Of The New Man*, came the end of what might be termed the period of explicit surrealism. For the next twenty years the great themes of Christianity preoccupied Dalí, as in *Christ Of St. John On The Cross*. After the small canvasses of the early Surrealist period, with their often deserted terrains, Dalí embarked upon a series of enormous paintings, crowded with incident and detail, such as *The Oecumenical Council*.

(4) The nuclear phase. Dalí's marriage with the age of physics. In addition to his religious preoccupations, Dalí was fascinated by new discoveries in atomic physics. Many of his most serene paintings, such as *Raphaelesque Head Exploding*, date from this more recent period. Here the iconography of nuclear physics is used to invest his madonnas and religious heroes with the unseen powers of the universe.

The strong element of humour in Dalí's appraisal of himself and the world around him – an ironic, perverse but wholly serious commentary – reminds us of the generous and unflagging way in which he has entertained us for over half a century, and in the face, moreover, of a usually hostile and derisory audience. But his place in the pantheon of master-artists of the 20th century is already secure, reserved from the moment he completed his first masterpiece, the classic *Persistence Of Memory*, with its soft watches and flaccid embryos expiring on a fused beach. At their best, Dalí's paintings reveal in the most powerful form the basic elements of the Surrealist imagination: a series of equations for dealing with the extraordinary transformations of our age. Let us salute this unique genius, who has counted for the first time the multiplication tables of obsession, psychopathology and possibility.

"It is not necessary for the public to know whether I am joking or whether I am serious, just as it is not necessary for me to know it myself."
SALVADOR DALÍ, IN 'DALÍ'; HARRY N. ABRAMS INC., NEW YORK, 1968.

PROLOGUE

SALVADOR DALÍ

*"There is a greater difference between one man and another than between
two animals of different species."*
MICHEL DE MONTAIGNE.

Ever since the French Revolution there has been growing up a vicious,
cretinising tendency to consider a genius as a human being more or less the same
in every respect (apart from his work) as ordinary mortals. This is false. And if
it is false when applied to me, the genius of the greatest spiritual order of our
day, a true modern genius, it is even more false when applied to those who, like
the almost divine Raphael, embodied the very genius of the Renaissance.

This book will prove that the daily life of a genius, his sleep, his
digestion, his ecstasies, his nails, his colds, his blood, his life and death are
essentially different from those of the rest of mankind. This unique book, then,
is the first diary written by a genius. And it is more than that: it is written by
the unique genius who has had the unique fortune to be married to the genius
Gala, the unique mythological woman of our time.

Of course, all will not be said today. There will be blank pages in this
diary, which covers the years 1952 to 1963 of my re-secret life. At my request,
and in agreement with my publisher, certain years and certain days will remain
unpublished for the time being. Democratic societies are unfit for the
publication of such thunderous revelations as I am in the habit of making. The
unpublished parts will appear later in the next eight volumes of the first series
of *Diary Of A Genius* – circumstances permitting; otherwise they will appear in
a second series, by which time Europe will have restored her traditional
monarchies. In the meantime, dear readers, I ask you to hold your breath and
to learn all you can about the atom that is Dalí.

Such are the unique and prodigious, but also wholly true, reasons why
all that will now follow, from the first word to the last (and without my having
to do anything about it), will inevitably be a work of genius, through and
through, and for the sole reason that it is the faithful diary of your faithful and
humble servant,

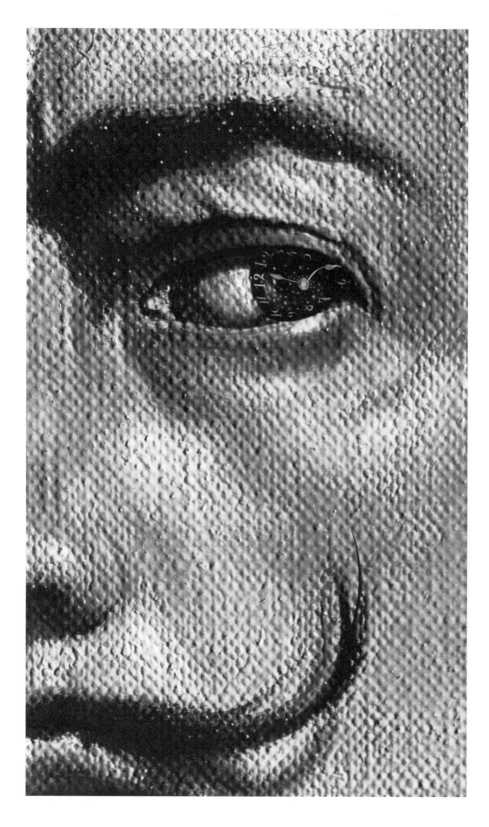

DIARY OF A
GENIUS

I dedicate this book to my genius Gala Gradiva,
Helen of Troy, Saint Helen, Gala Galatea Placida

1952

May

Port Lligat, the 1st

*"He is a hero who revolts against paternal authority
and conquers it."*
SIGMUND FREUD

To write the following, I am wearing for the first time some patent-leather shoes that I have never been able to wear for long at a time, as they are horribly tight. I usually put them on just before giving a lecture. The painful pressure they exert on my feet goads my oratorical capacities to their upmost. This sharp and overwhelming pain makes me sing like a nightingale or like one of those Neapolitan singers who also wear shoes that are too tight. The visceral physical longing, the overwhelming torture provoked by my patent-leather shoes, forces me to extract from words distilled and sublime truths, generalised by the supreme inquisition of the pain that my feet suffer. So I put on my shoes and I begin to write down, masochistically and without haste, the whole truth about my exclusion from the Surrealist movement. I care nothing for the calumnies hurled at me by André Breton, who cannot forgive me for being the last and the only Surrealist, but it is important that some day, when I publish these pages, everyone should know what really happened. To explain this I must go back to my childhood. I was never capable of being an average pupil. I would either seem completely unteachable and give the impression of being utterly dumb, or I would fling myself on my work with a frenzy, an application and a will to learn that astonished everybody. But to awaken my zeal, it was necessary to offer me something I liked. Once my appetite had been whetted, I became ravenously hungry.

My first teacher, Don Estaban Trayter, repeated to me for a year that God did not exist. Peremptorily, he would add that religion was 'a woman's business'. Even though I was very young, this concept delighted me. To me it seemed strikingly true. I could see the truth of it every day in my own family, for only the women went to church and my father refused to go, calling himself a freethinker. To emphasise the freedom of his thoughts, he would embellish

everything he said with enormous and picturesque blasphemies. If anyone objected he would quote his friend Gabriel Alamar's aphorism: 'Blasphemy is the most beautiful ornament of the Catalan language.'[1]

I have tried elsewhere to recount my father's tragic life. It is worthy of Sophocles. In fact my father is the man I have not only most admired but also most imitated, though I made him suffer a great deal. I pray God will keep him in His sacred glory, though I am sure he must be there already, for the three last years of his life were distinguished by a profound religious crisis which afforded him the consolation and final pardon of the last sacraments. But in this period of my childhood, when my mind was thirsting after knowledge, I found only atheistic books in my father's library. Looking through them, I carefully noted, leaving no proof untested, that God does not exist. I read with incredible patience the Encyclopedists, whom I nowadays find unbearably dull. Every page of Voltaire's *Philosophical Dictionary* provided me with the arguments of a man of law (like those of my father, who was a notary) as to the non-existence of God.

My first dose of Nietzsche shocked me profoundly. In black and white he had had the audacity to affirm: 'God is dead!' What? I had just learned that God did not exist, and now someone was informing me that He had died. My first doubts were born. To my mind Zarathustra was a magnificent hero whose greatness of soul I admired, but at the same time he betrayed himself by puerilities that I, Dalí, had already left behind me. One day I would be greater than he! The day after I first started reading *Thus Spoke Zarathustra* I had already made up my mind about Nietzsche. He was a weakling who had been feckless enough to go mad, when it is essential, in this world, not to go mad! These reflections furnished the elements of my first motto, which was to become the theme of my life: 'The only difference between a madman and myself is that I am not mad!' It took me three days to assimilate and digest Nietzsche. After this lion's banquet, only one detail of the philosopher's personality was left for me, only one bone to gnaw: his moustache! Later, Federico Garcia Lorca, fascinated by Hitler's moustache, was to say: 'The moustache is the tragic constant in the face of man.' Even in the matter of moustaches I was going to surpass Nietzsche! Mine would not be depressing, catastrophic, burdened by Wagnerian music and mist. No! It would be line-thin, imperialistic, ultra-rationalistic, and pointing towards heaven, like the vertical mysticism, like the vertical Spanish syndicates.

It is true that Nietzsche, instead of driving me further into atheism, initiated me into the questions and doubts of pre-mystical inspiration, which was to reach its glorious culmination in 1951 when I drew up my *manifesto*;[2] but on the other hand his personality, his pilose system, and his intransigent

1. In his first autobiography *Secret Life* Dalí has mentioned Trayter, this strange teacher who during his first year at school made him unlearn what little he knew of the alphabet and counting.

2. *Mystical Manifesto* by Salvador Dalí (Paris, 1952).

attitude towards the lachrymose and sterilising virtues of Christianity, contributed inwardly to the development of my anti-social instincts and my lack of family feeling, and outwardly to the transformation of my appearance. After reading *Zarathustra* I allowed my sideburns to cover my cheeks to the corners of my mouth and my jet-black hair to grow as long as a woman's. Nietzsche awoke in me the idea of God. But the archetype that he had set before me to admire and imitate was enough to make my family turn me out. I was banished by my father for having studied too closely and followed too literally the atheist and anarchist teachings of his books – banished by my father who could not tolerate my surpassing him in everything I did, especially since my blasphemies were even more virulent than his.

The four years that preceded my expulsion from my family, I spent in a state of constant and extreme 'spiritual subversion'. To me those four years were truly Nietzschean. My life during that period would be incomprehensible if it were not considered within the context of that atmosphere. This was the period when I was put in jail in Gerona, when one of my paintings was rejected for obscenity in the autumn exhibition at Barcelona, when I sent insulting letters, co-signed with Buñuel, to the humanist doctors and to all the most distinguished personalities in Spain, including Nobel prize-winner Juan Ramón Jimenez. Most of the time these demonstrations were quite unjust, but I intended in this way to assert my 'will to power' and to prove that I was still impervious to regret. My superman was destined to be nothing less than a woman, the superwoman Gala.

When the Surrealists discovered in the house of my father, at Cadaqués, the picture that I had just finished painting and that Paul Eluard had baptised *The Lugubrious Game*, they were scandalised by the scatological and anal elements of the image represented. Gala in particular objected to my work with a vehemence which disgusted me at the time, but which I have since learned to adore. I was prepared to join the Surrealist movement. I had studied their watchwords and their themes thoroughly, dissecting them down to the smallest bones. I had understood that the point was to transcribe thought spontaneously, without rational, aesthetic or moral checks. And now, before I had so much as entered the group with the best will in the world, they were going to enforce restrictions upon me similar to those of my family. Gala was the first to warn me that among the Surrealists I would suffer the same vetoes as elsewhere, and that they were all ultimately bourgeois. My strength, she could foresee, would be to maintain an equal distance from all artistic and literary movements. With an intuition which at the time was greater than mine, she added that the originality of my method of paranoiac-critical analysis would have sufficed for any member of the group to found a separate school. My Nietzschean dynamism refused to listen to Gala. I categorically refused to consider the Surrealists as just another literary and artistic group. I believed they were capable of liberating man from the tyranny of the 'practical, rational world'. I was going to become the Nietzsche of the irrational. I, the obsessed rationalist,

was the only one who knew what I wanted: I was not going to submit to irrationality for its own sake, to the narcissistic and passive irrationality the others practised; I would do completely the opposite, I would fight for the 'conquest of the irrational'.[3] In the meantime my friends were to let themselves be overwhelmed by the irrational, were to succumb, like so many others – Nietzsche included – to that romantic weakness.

Having finally absorbed everything the Surrealists had published, and imbued with Lautréamont and the Marquis de Sade, I entered the group, armed with a Jesuitical good faith, but determined to become its leader as soon as possible. Why should I burden myself with Christian scruples concerning my new father, André Breton, when I had none for the one who had brought me into the world?

So I took surrealism literally, neglecting neither the blood nor excrements on which its advocates fed their diatribes. In the same way that I had applied myself to becoming a perfect atheist by reading my father's books, I was such a conscientious student of surrealism that I rapidly became the only 'integral Surrealist'. To such a degree that I was finally expelled from the group because I was too Surrealist. The alleged reasons for this I considered to be of the same nature as those which had prompted my expulsion from my family, Gala-Gradiva, 'she who advances', 'the Immaculate intuition', had been right once again. Today I can say that of all my certainties, there are only two that cannot be explained by my will to power: one is my faith, which I rediscovered in 1949, and the other is that Gala will always be right about my future.

When Breton discovered my painting, he was shocked by the scatological elements that stained it. This surprised me. I started from shit, which from the psychoanalytical point of view could be interpreted as the happy omen of the gold that – fortunately! – threatened to pour down on me. Subtly, I tried to make the Surrealists believe that these scatological elements could only bring luck to the movement. Invoke though I might the digestive iconography of all ages and all civilisations – the hen that laid the golden eggs, the intestinal delirium of Danaë, the ass whose dung was gold – they refused to trust me. I made up my mind at once. Since they would have nothing to do with the shit I offered them so generously, I would keep these treasures and this gold for myself. The famous anagram laboriously composed twenty years later by Breton, 'Avida Dollars', might have been proclaimed even at that time.

A mere week spent with the Surrealists was enough to show me that Gala was right. They tolerated to a certain extent my scatological elements. On the other hand a number of other things were declared 'taboo'. Here I recognised the same prohibitions I had encountered in my family circle. Blood they allowed me. I could add a bit of shit. But shit on its own was not allowed. I was authorised to represent the sexual organs, but not anal fantasies. Any anus was taken in very bad part. They rather liked lesbians, but not pederasts. In

3. *The Conquest Of The Irrational* by Salvador Dalí (Paris, 1935).

dreams, one could use sadism, umbrellas and sewing machines at will but, except for obscenities, any religious element was banned, even of a mystical nature. If one simply dreamed of a Raphael madonna without any apparent blasphemies, one was not allowed to mention it.

As I have already said, I had turned 100 per cent Surrealist. Anxious to preserve my good faith, I decided to push my experiment to its extreme and contradictory consequences. I felt I was ready to act with that Mediterranean and paranoid hypocrisy of which I believe I alone am capable in my perversity. The important thing for me then was to commit the maximum number of sins, though I was deeply impressed by the poems of St. John of the Cross which I knew only from having heard Garcia Lorca recite them with exaltation. I already had a premonition that the question of religion would come up later in my life. Imitating St. Augustine, who indulged in libertine behaviour and orgiastic pleasure while praying to god for faith, I invoked heaven, adding: 'But not yet. In a little while ...' Before my life was to become what it is now, an example of ascetism and virtue, I wanted to cling to my illusory surrealism of a polymorphous pervert, if only for three more minutes, like the sleeper who struggles to retain the last fragments of a Dionysian dream. The Nietzschean Dionysus accompanied me everywhere like a patient governess and soon I could not help noticing that he was wearing a swastika armband. Things were going to be spoiled by those who were already rotting.

I have never denied my fertile and elastic imagination the most rigorous means of investigation. But these only served to confirm my congenital craziness. This is why I made a great effort, even while I was part of the Surrealist movement, to gain acceptance every day for an idea or an image that was completely opposed to the 'Surrealist fashion'. In fact, everything I proposed went against their wishes. They did not like anuses! I tried to trick them by giving them lots of anuses, carefully dis-simulated, and preferably Machiavellian ones. If I constructed a Surrealist object in which no fantasy of this type appeared, the symbolic functioning of this object would be anal. I opposed pure and passive automatism with the active impulse of my famous method of paranoiac-critical analysis. In addition, I confronted the enthusiasm for Matisse and abstract tendencies with the ultra-regressive and subversive technique of Meissonier. In order to defeat primitive objects, I launched the vogue for hyper-civilised objects of the '1900 style' which we used to collect with Dior and which were one day to come back into fashion with the 'new look'.

At the very moment when Breton did not want to hear any more about religion, I was preparing, of course, to invent a new religion which would be at once sadistic, masochistic, and paranoiac. I got the idea for my religion from reading the works of Auguste Comte. Perhaps the Surrealist group might be able to achieve what the philosopher had been unable to accomplish. But first I had to make the future high priest, André Breton, interested in mysticism. I intended to explain to him that if the things we defended were true, we would

have to add to them a mystical and religious element. I admit that at that period I already anticipated that we would return to the truth of the Apostolic Roman Catholic religion, which was slowly beginning to overwhelm me with its glory. Breton received my explanations with a smile and kept reverting to Feuerbach, whose philosophy we now know to have idealistic holes in it – though at the time we did not realise this.

While I was reading Auguste Comte in order to establish my new religion on a solid basis, Gala turned out to be the more positivist of the two of us. Indeed, she spent her days in paint shops, with antique dealers and restorers, buying brushes, varnish, and all the materials that would enable me to start painting as soon as I decided to stop pasting colour reproductions and bits of paper on to my canvases. Of course I would not hear anything about technique while I was busy creating the Dalínian cosmogony, with its limp watches which prophesied the disintegration of matter, its fried eggs without a frying pan, its hallucinating and angelic phosphenes, reminiscent of the intra-uterine paradise lost on the day of my birth. I did not even have time to paint it all as it should have been. It was good enough if my meaning was clear. The next generation would see to it that my work was finished and refined. Gala did not agree with me. Like a mother with a child that will not eat, she insisted:

'Now look, little Dalí, try this very, very special substance. It is liquid amber – amber that has not been burnt. They say Vermeer used to paint with it.'

With a disgusted and wistful expression, I tried it. 'Yes! I can see that this amber has its merits. But you know very well I have no time to go into these details. I can do much better. I have an idea! An idea that will scandalise the whole world and especially the Surrealists. No one will be able to say anything against it because I have dreamed twice of this new William Tell! It's about Lenin. I want to paint him with one buttock nine feet long and propped up on a crutch. I'll need a canvas eighteen feet long for it ... I'll paint my Lenin with his lyrical appendage even if they throw me out of the Surrealist group. He'll be holding a little boy in his arms – me. But he'll be staring at me cannibalistically, and I'll be crying out: "He wants to eat me!"

'I'm not going to tell Breton!' I added, deep in visions that reached such speculative heights that, as often happens when I am in this state, I wet my pants!

'All right,' Gala repeated softly. 'Tomorrow I'll bring you some amber dissolved in spike oil. It costs a fortune, but I want you to use it when you're painting your new Lenin.'

To my great disappointment Lenin's lyrical buttock did not scandalise my Surrealist friends. This very disappointment encouraged me. So I could go even further ... attempt the impossible. Aragon was the only one who objected to my thinking machine adorned with goblets of hot milk.

'Enough of Dalí's eccentricities!' he exclaimed angrily. 'From now on, milk will be for the children of the unemployed.' Breton took my side. Aragon

made himself completely ridiculous. Even my family would have laughed at my idea, but he was already following a backward political concept that was to lead him where he is now – that is, more or less nowhere.

During this time, Hitler was Hitlerising, and one day I painted a Nazi children's nurse knitting. She had accidentally sat down in a big puddle of water. At the insistence of some of my most intimate Surrealist friends, I had to paint out her swastika armband. I had never expected the emotions that would be aroused by this emblem. I became so obsessed with it that I projected my delirium on to the personality of Hitler, who always appeared to me as a woman. Many of the paintings I did at this period were destroyed when the German Army invaded France. I was fascinated by Hitler's soft, round back, always so tightly encased in its uniform. Every time I started painting the leather strap that ran from his belt across the opposite shoulder, the softness of the Hitlerian flesh squeezed into the military tunic brought me to a state of ecstasy that was simultaneously gustatory, milky, nutritive and Wagnerian, and made my heart beat violently, a very rare emotion I don't experience even when I'm making love. Hitler's chubby flesh, which I imagined to be like the most opulent feminine flesh with the whitest skin, fascinated me. Conscious nonetheless of the psycho-pathological nature of such transports, I was thrilled to whisper into my own ear:

'Yes, this time I believe I'm on the verge of true madness!'

And to Gala:

'Bring me some amber in spike oil and the finest brushes in the world. Nothing will be delicate enough to paint, in the ultra-regressive manner of Meissonier, the super-nutritive delirium, the mystic and carnal ecstasy that seizes me when I set about putting on canvas the impression of the leather strap on Hitler's flesh.'

No matter how often I assured myself that my Hitler-inspired vertigo was apolitical, that the work generated by the feminised image of the Führer was of a scandalous ambiguity, that these representations were tinged with the same degree of morbid humour as those of William Tell or Lenin – no matter how often I repeated all this to my friends, it was no use. This new crisis in my painting aroused greater and greater suspicion among the Surrealists. Things grew still worse when news spread that Hitler would have liked the swans, the solitude, the megalomania, the Wagnerism, and all the touches of Hieronymus Bosch I had been putting into some of my paintings.

With my congenital sense of contradiction, things were bound to get worse. I asked Breton to call an urgent special session of our group in order to discuss the Hitlerian mystique from the point of view of the Nietzschean and anti-Catholic irrational. I was hoping the anti-Catholic aspect of the discussion would tempt Breton. In addition, I considered Hitler a complete masochist possessed by the idea of provoking a war in order to lose it heroically. In fact, he was preparing one of those gratuitous acts which were at the time very much appreciated by our group. My insistence on considering Hitler's mystique from

the Surrealist point of view, as well as my insistence on giving a religious meaning to the sadistic element in surrealism, both of which were aggravated by the developments of my paranoiac-critical method of analysis, which tended to deprecate automatism and its inherent narcissism, ended in a series of breaks and intermittent rows with Breton and his friends. Besides, his friends began to waver between him and me in a way that was alarming to the movement's leader.

I painted a prophetic picture of the Führer's death. It was called *The Enigma Of Hitler*, and it brought me excommunication by the Nazis and cheers from the anti-Nazis, even though the painting – and, by the way, this applies to anything I've ever done, and I shall say so to the end of my days – lacked all conscious political significance. At the moment I write these lines, I must confess I have not yet deciphered this famous enigma.

One evening the Surrealist group was convened to pronounce judgment on my so-called Hitlerism. Unfortunately I have forgotten most of the details of this very peculiar session. But if Breton wants to see me again someday, I wish he would let me know what was in the minutes that must have been compiled after that meeting. At the time of my expulsion from the Surrealist group I was suffering from the beginnings of a sore throat. Always alarmed whenever I feel sick, I attended with a thermometer in my mouth. I think I must have taken my temperature at least four times during my trial which lasted far into the night, for when I returned home, dawn was breaking over Paris.

While I was pleading *pro domo*, I knelt down several times, not to plead against being expelled, as has been falsely said, but, on the contrary, to exhort Breton to understand that my obsession with Hitler was strictly paranoid and essentially apolitical. I also explained that I could not be a Nazi, because if Hitler conquered Europe he would seize the opportunity to do away with all hysterical characters like myself, as he had already done in Germany by treating them as degenerates. Finally the feminine and irresistibly silly role that I attributed to Hitler's personality would be sufficient to classify me as an iconoclast in the eyes of the Nazis. Similarly my fanaticism, aggravated by Freud and Einstein, both of them forced out of Germany by Hitler, made it obvious that the latter interested me only as an object of my delirium and because he seemed to me of incomparable catastrophic value.

In the end they were convinced of my innocence, but all the same I had to sign a document in which, among other things, I declared myself not to be an enemy of the proletariat. I signed this without any qualms, as I have never had any particular feelings either for or against the proletariat.

The truth, sole and indivisible, suddenly became obvious: it was impossible to be a thorough-going Surrealist in a group that was guided only by the political motives of partisans, and this in every respect, whether it applied to Breton or Aragon.

Someone like myself, who claimed to be a real madman, living and organised with Pythagorean precision (in the Nietzschean sense of the word),

could not possibly exist. What was bound to happen duly happened: Dalí, the complete Surrealist, preaching an absolute absence of aesthetic or moral constraint, actuated by Nietzsche's 'will to power', asserted that every experiment could be carried to its extreme limits, without any break in continuity. I demanded the right to make Lenin grow buttocks nine feet long, to garnish his portrait with jellied Hitlers spiced, if need be, with Roman Catholicism. Each man was free to become or to abandon another being: pederast, coprophage, virtuous or ascetic in the transports of his digestive or phosphenomatic upsets. The polymorphous pervert that I had been during my adolescence now attained an hysterical summit: my jaws pulverised Gala, I fell in love with the most transcendentally ammoniacal and putrid donkeys. The smells of human bodies naturally became liturgical for me. Humanitarian sentiments prevented the blossoming of anal stinks and ecstasies (without anus), clean or dry, like doubly, trebly or quadruply bound visceral shrivellings. Over everything rose the huge, extenuated, and hydroptic faces of the great and glorious masturbators, decked out in their Communist-faced grasshoppers, with their Napoleonic bellies, their Hitlerian thighs that clung effeminately to my mouth. And it was all only just beginning!

But Breton said 'No' to Dalí! And in some respects he was right, because in this conglomeration he wanted at least to be able to choose good and evil, good and evil ... Yet he was also a bit wrong, because even when maintaining freedom of choice, it was necessary to surrender to this Dalínian assortment which was as truculent as it was succulent. If he was not entirely right, that was because Dalí, the absolute rationalist, wanted to know all about the irrational, not in order to make it into a new literary and human repertoire, but on the contrary to reduce and subjugate this irrational whose conquest he was making. The cyclotron of Dalí's philosophical jaws was craving to pulverise and bombard everything with the artillery of his intra-atomic neutrons, in order to transform to pure mystic energy the vile visceral and ammoniacal conglomeration of biology to which the Surrealist dream gave access. Once this putrefying profusion had been completely and definitively spiritualised, man's mission and purpose on earth would be fulfilled, and all would be treasure.

This was the moment chosen by the siren Kierkegaard to sing like a stinking little nightingale. And all the existentialist sewer rats that had been fornicating in the basements during the occupation, spat and screamed their disgust at the left-overs of the Surrealist banquet which we had allowed to grow cold inside them as if in garbage cans. Everything was splendidly vile, and man himself was superfluous.

'No!' Dalí called out to them. Not before everything has been rationalised. Not before each libidinous terror of ours has been ennobled and sublimated by the supreme beauty of death, following the path that leads to spiritual perfection and to asceticism. Only a Spaniard could fulfil this mission among the ugliest and most demoniacal discoveries of all time. Everything had to be cleansed, and the metaphysical geometry invented.

It was necessary to turn to the silver oxide and olive-green dignity of Velasquez and Zurbaran, to the realism and mysticism that we were to discover to be alike and consubstantial. Transcendent reality had to be integrated into some fortuitous part of pure reality, such as Velasquez' absolute visual imperialism had achieved. But this already presupposed the uncontested presence of God, Who is the only supreme reality!

This Dalínian attempt at rationalisation was timidly and not very consciously made in the magazine *Le Minotaure*. Picasso had asked Skira, the publisher, to have me illustrate the *Chants De Maldoror*. One day Gala arranged a lunch with Skira and Breton. She was made editor of the magazine, and the *Minotaure* was born under these uncertain auspices. Today, on another level, the most tenacious effort at rationalisation is being made, I believe, by the very beautiful publication *Etudes Carmélitaines*, edited by Father Bruno, whom I greatly admire. Let us not speak about the unhappy fate of *Le Minotaure*, which is now grazing in the materialistic fields of *Verve*.

On two other occasions I was hypocritically to discuss my future religion with Breton. He did not understand. I stopped insisting. We saw less and less of each other. When Breton arrived in New York in 1940 I telephoned him on the day of his arrival to welcome him and to make an appointment; we arranged to meet the next day. I announced to him a new ideological platform for our ideas. We would start a great mystical movement intended in a sense to enhance our Surrealist experiment and to set it apart, once and for all, from dialectical materialism! But the same evening, friends told me that Breton had just been calumniating me again, calling me an admirer of Hitler. This was too false and dangerous a thing to do, at that period, for me still to agree to see him. We have not met since.

Nevertheless, thanks to the years that have passed and to my innate intuition which is as accurate as a Geiger counter, I feel that Breton is closer to me. His intellectual activity, despite appearances, has a value that is lacking in the existentialists, for all their theatrical and transient successes.

Ever since the day I did not keep my appointment with Breton, surrealism as we had defined it has been dead. The next day, when a big newspaper asked me to define surrealism, I answered: 'I am surrealism!' And I believe it, because I am the only one who is carrying it on. I have repudiated nothing; on the contrary, I have reaffirmed, sublimated, hierarchised, rationalised, dematerialised, spiritualised everything. My present nuclear mysticism is merely the fruit, inspired by the Holy Ghost, of the demoniacal and Surrealist experiments of the first part of my life.

Meticulously Breton composed a vindictive anagram on that admirable name of mine, transforming it into 'Avida Dollars'. This was perhaps not the masterpiece of a great poet. All the same, in the context of my life's history I must admit that it corresponded rather well to my immediate ambitions of that moment. As a matter of fact, Hitler had just died in a highly Wagnerian manner in Eva Braun's arms in Berlin. As soon as I heard the news I reflected seventeen

minutes[4] before taking an irrevocable decision: Salvador Dalí was going to become the greatest courtesan of his time. And so I did. It is the same way with everything that I undertake to achieve in a paranoiac rage.

After Hitler's death, a new mystical and religious era began to devour all ideologies. In the meantime I had a mission. Modern art, dusty residue of the materialism inherited from the French Revolution, was to oppose me for at least ten years. Now, I had to paint *well*, something that would be of no interest to anybody whatsoever. However it was indispensable to paint *well*, because my nuclear mysticism could triumph on the appointed day only if it was incarnated in the most supreme beauty.

I knew that the art of the abstract painters – those who believe in nothing and consequently paint *nothing* – would serve as a glorious pedestal for a Salvador Dalí isolated in our abject age of materialistic decorativism and amateur existentialism. All this was certain. But in order to stand firm, I would have to be stronger than ever, to have money, to make gold, fast and well, in order to hold out. Money and health! I stopped drinking altogether and took the most exaggerated care of myself. At the same time I polished Gala to make her shine, making her as happy as possible, taking even better care of her than of myself, for without her all would be finished. We would use the money to do all we wanted to do in the way of beauty and goodness. My 'Avida Dollars' had no more to it than that. The proof is being demonstrated today ...

What I like best in all the philosophy of Auguste Comte is the precise moment when, before founding his new 'positivist religion', he places at the summit of his hierarchy the bankers to whom he attaches capital importance. Perhaps it is the Phoenician side of my Ampurdan blood, but I have always been greatly impressed by gold in whatever form. Ever since adolescence, when I learned that Miguel de Cervantes, having written his *Don Quixote* for the greater glory of Spain, died in blackest penury, and that Christopher Columbus, having discovered the New World, also died under the same conditions and in prison as well – as I say, ever since adolescence, my prudence has strongly advised me upon two matters:

1. To make my prison as early as possible. And this was done.

2. To become, as far as possible, something of a multi-millionaire. And this too has been done.

The simplest way not to have to make any concessions to gold is to have it oneself. When one is rich, it becomes completely useless to be 'committed'. A hero enters into no commitments! He is the exact opposite of the domestic. As the Catalan philosopher Francesco Pujols has so rightly observed: 'The greatest aspiration of man on the social level is the sacred freedom to live without the need to work.' Dalí completes this aphorism by

4. At that moment, he took his temperature. Gala told him: 'Two minutes is enough.' 'To be really sure,' he answered, 'I'll keep it in for another fifteen.'

adding that this freedom in its turn conditions human heroism. The only way to spiritualise matter is to fill everything with gold.

I am the son of William Tell, who has transformed into solid gold the apple of 'cannibalistic' ambivalence which his fathers, André Breton and Pablo Picasso, had in their turn placed precariously on his head. That head, so fragile and so beloved by Salvador Dalí! Yes, I believe I am the saviour of modern art, the only one capable of sublimating, integrating and rationalising imperially and beautifully all the revolutionary experiments of modern times, in the great classical tradition of realism and mysticism which are the supreme and glorious mission of Spain.

The role of my country is essential to the great movement of 'nuclear mysticism' which must characterise our times. America, because of the unheard-of progress of its technology, will produce the empirical (we might even call them the photographic or microphotographic) proofs of this new mysticism.

The genius of the Jewish people will involuntarily give it, thanks to Freud and Einstein, its dynamic and anti-aesthetic possibilities. France will play an essentially didactic role. She will probably draw up the constitutional form of 'nuclear mysticism' owing to her intellectual prowess. But, once again, it will be the mission of Spain to ennoble all by religious faith and beauty.

The anagram 'Avida Dollars' was a talisman for me. It rendered the rain of dollars fluid, sweet, and monotonous. Someday I shall tell the truth about the way in which this blessed disorder of Danaë was garnered. It will be a chapter of a new book, probably my masterpiece: *On The Life Of Salvador Dalí Considered As A Work Of Art*.

In the meantime I want to record an anecdote. One very successful evening as I was coming back to my apartment in St. Regis Hotel in New York, I heard a metallic sound in my shoes after having paid for my taxi. I took off my shoes and found in each of them a fifty-cent piece. Gala, who had just awakened, called out to me from her room:

'Dalí, my dear! I was just dreaming that the door was ajar and that I saw you with some other men ... You were weighing gold...!'

I crossed myself in the dark and murmured nobly:

'So be it!'

Whereupon I embraced

my talatiev, my treasure, my weight in gold!

June

Children have never particularly interested me, but what interest me even less are the paintings by children. The child-painter knows his picture is badly painted and the child-critic also knows that he knows it is badly painted. Then the child-painter-critic who knows that he knows that he knows that it is badly painted has only one recourse: to say that it is very well painted.

the 29th

Thank God, in this period of my life I *sleep* and I *paint* even better and with more satisfaction than usual. So much so that I have to remember to avoid the painful cracks that seem to occur at each corner of my mouth, the unpleasant physical consequence of the saliva accumulated by the pleasure afforded by these two divine ardours – sleeping and painting. Yes, sleeping and painting make me slaver with pleasure. Of course, with a rapid or lazy movement of the back of my hand, I could wipe my face during one of my paradisiacal awakenings or one of the no less paradisiacal pauses during my work, but I am so completely addicted to my vital and intellectual ecstasies that I do not do so! Now here is a moral problem that I have not solved. Should one let the cracks of satisfaction become worse, or should one force oneself to wipe away the saliva in time? Pending a solution, I have invented a new somniferous method, a method that must be included some day in the anthology of my inventions. In general, people take sleeping pills when they have trouble going to sleep. I do the exact opposite. It is during the periods of my life when my sleep attains its maximum degree of regularity and its vegetable paroxysm that I, with a certain coquetry, decide to take a sleeping pill. Truly, and without indulging in even a hint of metaphor, this makes me sleep like a log and I wake up completely rejuvenated, my intelligence glittering with a new vigour that does not abate till the very tenderest ideas have reached their full bloom. This happened to me this very morning because last night I took a pill to make the cup of my present equilibrium overflow. And what an awakening, at half past eleven, on my terrace where I had my coffee and cream and honey in the sun, under a cloudless sky and without being inconvenienced by the vaguest erection!

I took a nap between half past two and five o'clock, with last night's pill continuing to make my cup overflow and also my saliva, for when I opened my eyes I noticed, from my wet pillow, that I must have slavered copiously.

Nevertheless I told myself: 'No, you won't begin wiping your face today, it's Sunday! And all the more reason not to, if you decide that the little

crack that is just beginning must be the last. In fact, it should become more distinct, so that you can appreciate the biological error and catch all its incidences in the raw.'

So I was awakened at five o'clock. The master mason Prignau had arrived. I had asked him to come and help me work out the geometrical aspects of my picture. We shut ourselves into the studio till eight o'clock, I sitting down and giving orders:

'Draw another octahedron, but one leaning more, now another concentric one ...'

And he, industrious and as agile as a prosaic Florentine pupil, produced everything almost as fast as I could utter my thought. Three times he made an error in his calculations, and each time, after a prolonged examination, I let out three piercing *kikirikis*, which I think upset him a bit. *Kikiriki* is the yell with which I relieve my great intensities. The three errors proved to be sublime. They achieved in an instant all that my brain was laboriously trying to find. When Prignau had left, I sat on in the dusk, dreaming. Afterwards I wrote with charcoal on the side of my canvas these words which I am now copying into my diary. As I copy them I like them even better:

'Mistakes are almost always of a sacred nature. Never try to correct them. On the contrary: rationalise them, understand them thoroughly. After that, it will be possible for you to sublimate them. Geometric preoccupations incline towards a utopia and do not favour erections. Besides, geometricians rarely get a hard on.'

the 30th

Another day destined chiefly to be one of slavering and salivating. I finished my breakfast at six in the morning, and as I was rather impatient to start on the great sky of my *Assumption*, I first assigned myself the task of painting meticulously one single scale, though the most brilliant and silvery there was, of a flying fish that was caught yesterday. I did not stop till I really saw the scale shimmer as if inhabited by the very light of my brush tip. Thus it was that Gustave Moreau wished to see gold come out of the tip of his brush.

This exercise is particularly liable to make me slaver, and I felt the crack in my lip getting sore and smarting, gleaming in harmony with the scale that served me as a model. In the afternoon I painted the sky till twilight, and it is always the sky that makes me slaver most. The little crack is burning away. It feels like a mythological worm gnawing away at the corners of my mouth, which reminds me of one of the allegorical figures in Botticelli's *Primavera*, with its fascinating and obscure vegetation. The same vegetation grows and ferments with my little crack in the rhythm of a Bach cantata, which I then immediately play very loudly on my gramophone.

Juan, my ten-year-old model, has come up to ask me out to play

football on the quay. To lure me, he has picked up a brush and is directing the end of the cantata with the most angelic gestures I have ever seen in my life. I am going down to the quay with Juan. The day is drawing to a close. Gala, a bit melancholy but more sun-tanned, more beautiful, and with her hair in a more becoming disorder than I have ever seen it in before, suddenly discovered a glow-worm that was shining as my fish scale had that morning.

This discovery reminded me of my first literary composition. I was seven years old and my story ran as follows: A child is taking a walk with his mother on an evening in June. It is raining falling stars. The child picks one up and carries it with him in the palm of his hand. When he gets home he puts it on his bed table and imprisons it in a glass. Next morning, when he wakes, he cries out in horror: during the night a worm has devoured his star! My father – may God preserve him! – was overwhelmed by this story which he always liked to think was far superior to Oscar Wilde's *Happy Prince*.

Tonight, I am going to fall asleep in full Dalínian continuity, under my great sky of the *Assumption*, painted under the brilliant scale of my rotten fish ... my chapped lip.

I should point out that all this is going on during the Tour de France cycle race, reported on the radio by Georges Briquet. The race leader, Bobet, had dislocated his knee. The heat is stupefying. I would like all France to be riding a bicycle, the whole world to be pedalling, the sweat streaming down, climbing inaccessible slopes like impotent madmen while the divine Dalí is painting the most delicious terrors in the sybaritic calm of Port Lligat. Oh yes, the French cycle race gives me such continuous satisfaction that my saliva flows in imperceptible but steady torrents to prolong at the swollen and crusty corners of my mouth, the stupid, Christian, stigmatising irritation of the cracks of my spiritual pleasure!

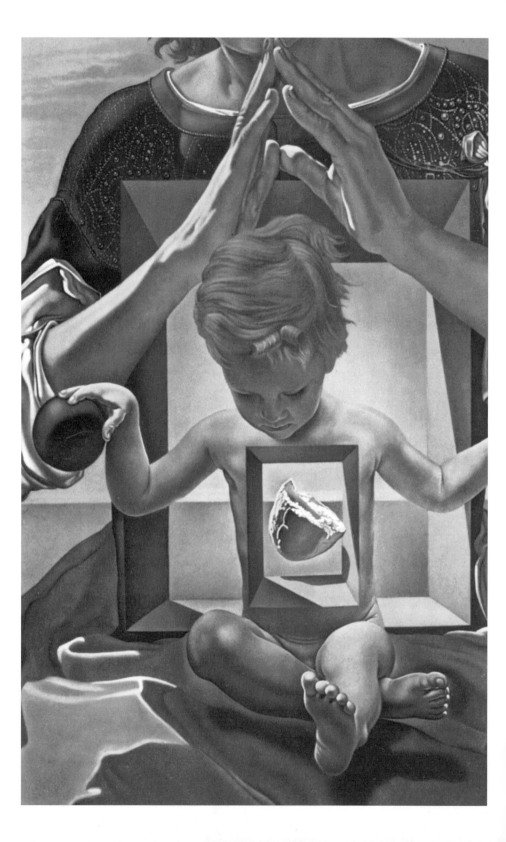

July

Port Lligat, the 1st

In July, neither women nor oysters.[5]

Awakened at six o'clock, my first movement is to touch my little crack with the tip of my tongue. It has dried up in the course of the night, which has been exceptionally warm and voluptuous. I am surprised, though, that it has dried so quickly, and that to the touch of my tongue it seems something hard that will come off like a scab. I say to myself: 'This is going to be fun.' I won't detach it immediately – that would be an imprudent waste of the delights of a laborious and patient day's work during which I shall play with my dry scab. Moreover, on this day I was to suffer one of the most harrowing experiences of my life because I turned into a fish! The story is well worth telling.

After a quarter of an hour during which I steeled myself, as I did yesterday morning, to set gleaming on my canvas some of the glittering scales of my flying fish, I had to break off because of a swarm of large flies (some of them greenish-gold) which had been attracted by the fetid odour of the corpse. These flies hovered between the nasty mess of the rotting fish and my face and hands, making it necessary for me to redouble my attentions and be twice as agile, as on top of the difficulty of the work itself I had to remain impervious to their bites, continuing unperturbed to perfect my strokes, painting the outline of a scale without so much as blinking, while at the same moment a fly clung frenziedly to my eyelid and three others glued themselves to the model. I had to take advantage of the brief moments when these flies changed position so that I could continue my observations; and then I have not even mentioned still another fly which insisted on settling on my crack. I could only chase it away by moving the corners of my mouth at short intervals, yielding to a violent rictus which was still harmonious enough not to interfere with the brush strokes applied while holding my breath. Sometimes I even managed to put up with it and not let it go till after I felt it frolicking on my scab.

Nevertheless it was not this prodigious suffering that obliged me to stop, because, on the contrary, the superhuman problem of painting while being devoured in this way by flies fascinated me and drove me to feats of agility I would not have been capable of without the flies. No! What made me stop was the smell of the fish which was so fetid it was about to make me throw up my breakfast. So I had my model taken away, and I began painting my Christ, but immediately the flies which till then had been divided between the fish and

5. Dalí still does not know why, but each year at this time he sends Picasso a postcard to remind him of this proverb.

myself collected exclusively on my skin. I was completely naked and my body had been spattered by a bottle of fixative that had fallen over. I suppose they were attracted by that liquid because I am really quite clean. Covered by flies I went on painting better than ever, defending my scab with my tongue and my breath. With my tongue I lifted and softened its outer layer, which seemed ready to detach itself. With my breath I dried it, harmonising my exhalations with the rhythm of my brush strokes. It was quite desiccated, and the intervention of my tongue would not have been enough to detach a thin flake if I had not helped with a convulsive grimace (made every time I took some colour off my palette). Now that thin flake had the exact quality of a fish scale. By repeating the operation an infinite number of times I could detach from myself any amount of fish scales. My crack was quite a factory of fish scales which looked like mica. As soon as I took one off, a new one instantly came into being at the corner of my mouth.

I spat the first scale on to my knee. By good fortune I had the highly sensitive impression that it stung me as it stuck to my flesh. I stopped painting at once and closed my eyes. I needed all my will power to remain motionless, there were so many hyper-active flies on my face. In anguish, my heart started beating like mad and I suddenly understood that I was identifying myself with my rotten fish as I felt myself going as rigid as it was. 'My God, I'm turning into a fish!' I exclaimed.

Proofs of the likelihood of this idea were immediately forthcoming. The scale from the crack burned on my knee and multiplied itself. I felt my thighs, first one then the other, and then my belly, growing scales all over. I wanted to savour this miracle and continued to keep my eyes closed for almost a quarter of an hour.

'Now,' I told myself, still incredulous, 'I'm going to open my eyes and see myself converted into a fish.'

Sweat was streaming down my body, and I was bathed in the warmth of the setting sun. Finally, I opened my eyes.

Oh! I was covered with shimmering scales!

But at the same moment I realised where they came from: it was only the dried splashes of my crystallised fixative. This was the moment the maid chose to bring me something to eat: toast dipped in olive oil. When she saw me she summed up the situation:

'You're as wet as a fish! And I don't understand how you can paint with all those flies torturing you!'

I stayed on my own, dreaming till dusk.

O Salvador, your metamorphosis into a fish, symbol of Christianity, only came about because of the torment of the flies. What a typically Dalínian crazy way to identify yourself with your Christ while you are painting Him!

With the tip of my tongue which is smarting from the day's work, I have finally managed to get the whole scab loose and not just one of its flimsy scales. And while writing with one hand I take the scab between the thumb and

index of the other, using infinite precaution. It is soft, but if I folded it, it would break. I hold it under my nose to smell it. It has no smell. Absent-mindedly I leave it for a moment between my nose and upper lip, which is lifted in a grimace that exactly summarises my feeling of being giddy with exhaustion. A blissful lassitude steals over me.

I have moved away from the table. The scab almost fell to the floor. I caught it in a plate, on my knees. But this has not made me give up my prostrate position, and I hold my mouth in a grimace as if I were fixed like that for eternity. Fortunately the joy of rediscovering my scab has roused me out of insurmountable torpor. In a panic I start looking for it on the plate where it is just one more brown spot among the innumerable crumbs of burned bread. I think I have it, and I pick it up between two fingers to play with it some more. But a terrible doubt has taken hold of me: I can no longer be sure which is my scab. I feel a great need for reflection. Here is an enigma resembling that of the other scales I had imagined myself producing. Since the dimension, the effect, and the absence of smell are the same, what does it matter whether it is the real scab or not? This comparison enrages me because it would simply mean that the divine Christ I am painting during my torment by flies has never existed!

This rage contracts my mouth in a paroxysm which together with my will to power forces the crack at the corner of my mouth to bleed. A long red oval drop runs into my goatee.

Yes, it is in the Spanish manner that I always sign my mad games! With blood, the way Nietzsche wanted it!

the 3rd

As usual, a quarter of an hour after breakfast, I slip a jasmine flower behind my ear and go to the toilet. I have hardly sat down before I have a bowel movement that is almost odourless. So much so that the perfumed toilet paper and my jasmine completely dominate the situation. This event might have been predicted by the blissful and extremely pleasant dreams of the night before, which in my case herald a smooth and odourless defecation. Today's movement is the purest of all, if that adjective is at all appropriate under the circumstances. I attribute it entirely to my nearly absolute asceticism, and I remember with repugnance and almost horror the bowel movements I used to have at the time of my Madrid debauches with Lorca and Buñuel, when I was twenty-one. It was the most unspeakable, pestilential ignominy, intermittent, spasmodic, splattering, convulsive, infernal, dithyrambic, existentialist, excruciating and bloody, compared to today's whose smoothly flowing continuity has made me think all day of the honey of a busy bee.

I had an aunt who was horrified by everything scatological. The very idea that she might break wind filled her eyes with tears. She staked her honour on the fact that she had never farted in her life. Today I consider her achievement less impressive than I used to. It is a fact that in my periods of

asceticism and intensive spiritual life, I cannot help noticing that I hardly fart at all. The assertion often encountered in old texts that the anchorite saints did not produce excrements, now seems closer to the truth, especially when we take into account the idea of Philippus Aureolus Theophrastus Bombastus von Hohenheim,[6] who explains that the mouth is not a mouth but a stomach, and that after chewing for a very long time without swallowing, if one spits out the food one is still nourished. The anchorites chewed and spat out roots and grasshoppers. It was faith and the naïve impression that they were already living in the atmosphere of heaven that gave them their euphoria.

The need to swallow – I described it a long time ago in my studies on cannibalism[7] – corresponds less to a nutritional need than to a compulsive necessity of an affective and moral order. We swallow in order to identify ourselves as absolutely as possible with the loved one. In the same way, we swallow the Communion bread without chewing it. This explains the antagonism between chewing and swallowing. The holy anchorite manages to separate the two things. In order to devote himself entirely to his ruminating role on earth (so to speak), he seeks to subsist through the exclusive use of his jaws, the act of swallowing thus being reserved for God alone.

the 4th

My life is regulated by a stop watch. Everything coincides. At the exact minute I finished painting, two visitors and their escorts come to the house. One is the Dalínian publisher from Barcelona in the heroic days, L.L., who announces that he has come from Argentina specially to see me (something he tells all his important friends, I think), and the other is Pla. L., the first to arrive, who tells me about his plans. He is going to publish four new books by or about me in Argentina.

1. A voluminous study by Ramón Gomez de la Serna for which I promise to give him some unpublished and astounding documents.

2. My Re-Secret[8] life which I am writing at the moment.

3. Hidden Faces by la Serna, which he has just bought in Barcelona.

4. Some enigmatic drawings of mine to accompany la Serna's text.

The last item requires illustrations by me. I decide that, on the contrary, it is he who will illustrate the book I am writing.

As for Pla., as soon as he arrives he repeats what he said at our last meeting: 'In the end, that moustache will puncture you!' Great effusions between him and L. To cut them short, I say that Pla. has just written an article which captures my capers with great perception. He answers:

6. Paracelsus, as he is also called (1493–1541).

7. It is true that Dalí has spoken of this in his *Secret Life*, but the complete study still remains to be published, in two or three volumes.

8. This is *Diary Of A Genius*, which Dalí was beginning to keep regularly.

'Tell me more things like that and I'll write as many articles as you like.'

'You'd write a book about me like nobody else.'

'I'll do it.'

'And I shall publish it,' L. exclaims. 'Besides, Ramón has almost finished one about Dalí.'

'But Ramón doesn't even know Dalí personally,'[9] Pla. says in disgust.

Suddenly my house has filled up with friends of Pla.'s. His friends are countless and hard to describe. Two details are characteristic: as a rule they have heavy eyebrows, and they always look as if they had been dragged away from a pavement café where they had been sitting for the last ten years.

Seeing Pla. off, I tell him:

'In the end, that moustache will puncture *you*. Now it has been decided in less than half an hour to publish five books by or about me! My strategy pays off in countless publications on my personality, and the important thing remains that my anti-Nietzschean moustache is still pointing to heaven like the spires of Burgos cathedral. Some day, because of me, people will be forced to take an interest in my work. This is much more effective than trying to grope for the artist's personality by way of his work. What would have fascinated me would be to know everything about the man Raphael.'

the 5th

The day that the good poet Loten, for whom I had done so many favours, presented me with my beloved rhinoceros horn, I said to Gala:

'This horn is going to save my life.'

Today that statement is beginning to come true. Painting my Christ, I notice that He is composed of rhinoceros horns. Like a man possessed, I paint every fragment of the anatomy as if it were the horn of a rhinoceros. When my horn is perfect, then – and only then – the anatomy of the Christ is equally perfect and divine. And when I notice that each horn implies another upside down, I start painting them interlaced. Immediately everything becomes even more divine, more perfect. I marvel at my discovery and fall on my knees to thank Christ for it – and this is no metaphor. You should see me dropping on my knees in my studio, like a real madman.

Artists, all through history, have been tormenting themselves to grasp form and to reduce it to elementary geometrical volumes. Leonardo always tended to produce eggs, which were the most perfect form, according to Euclid. Ingres preferred spheres, and Cézanne cubes and cylinders. But only Dalí, by the convolutions of his paroxysmal hypocrisy which had led him to an all-excluding obsession with the rhinoceros, has found the truth. All curved surfaces of the human body have the same geometric point in common: the one found in this

9. Of all these projects, only one materialised: the book of photographs called *Dalí's Moustache*, in which Dalí was able to start classifying each hair in his moustache by means of Halsman's photographs.

cone with the rounded tip curved towards heaven or towards the earth, and with the angelic inspiration of destruction in absolute perfection – the rhinoceros horn!

the 6th

A day of oppressive heat. On top of which I have some Bach playing on my gramophone at maximum volume. My head feels as if it is going to burst. I have knelt down three times to thank God, so well is the painting of the *Assumption* proceeding. At dusk a warm wind from the south gets up and the hills in the distance are ablaze. Gala comes back from lobster fishing and sends the maid to tell me to look at the sunset which is painting the sea the colour of amethyst, and then bright red. From my window I signal to her that I have noticed it. Gala is sitting in the prow of her boat which is painted Neapolitan yellow. This is the day I think she is more beautiful than at any time in my life. On the beach, the fishermen look at the flaming countryside. I kneel down once more to thank God that Gala is as beautiful a creature as those of Raphael. This beauty, I swear, is impossible to perceive, and nobody has been able to behold it as vitally as I, thanks to my previous ecstasies over my rhinoceros horns.

the 7th

Gala is even more beautiful!

I have received an invitation to attend the Elche mystery play[10] on the 14th of August. The dome of the church will be mechanically opened and angels will carry the Virgin off to heaven. Perhaps we shall go. From New York I am commissioned to write an article on the Lady of Elche.[11] Everything that is important coincides: this little village with its unique Lady, and the unique mystery of the Assumption, which they attempted to forbid, but which the Pope has just proclaimed as a dogma. For me, too, everything coincides, making each day heavier with purpose. I receive at the same time my text on the Assumption which will appear in the *Etudes Carmélitaines*. Father Bruno dedicates the magazine to me. I re-read what I have written and I confess that I like these pages tremendously. Thinking of the dried blood on my chapped mouth, I tell myself:
 'Promise and kept!'

The Assumption is the culminating point of Nietzsche's feminine will to power, the super-woman who ascends to heaven by the virile strength of her own antiprotons!

10. In the province of Alicante.

11. Sandstone bust found in the nineteenth century during excavations in Phoenician ruins.

the 8th

Two imbecile engineers have been to see me. I had heard them talking while they were climbing the hill. One of them was explaining to the other that he adored pine trees.

'Poor Lligat is too bare,' he said. 'I love pine trees; not so much for their shade, which I never use. I just love to look at them. A summer without seeing a pine tree would be no summer to me.'

I said to myself: 'Just wait! I'll get you and your pine trees!'

I receive the two gentlemen most kindly, forcing myself to keep up a conversation entirely made up of commonplaces. They are very grateful to me, but when they come out on to the terrace where I see them off, they notice my monumental elephant's skull.

'What's that?' one of them asks.

'An elephant skull,' I say. 'I love elephant skulls. Especially in summer. I couldn't really do without them. A summer without an elephant's skull would be inconceivable to me.'

the 9th

Deliciously aching with the desire to outdo myself. This divine dissatisfaction is the sign that something is growing inside my soul which will give me great satisfaction. At dusk I look out of the window at Gala, who seems to me to look even younger than the evening before. She is sailing in her new boat. In passing, she tries to caress our two swans which are standing on a little dinghy. But one flies off and the other hides under the bow.[12]

the 10th

I have received a letter from Arturo Lopez. According to him, I am the friend he likes best. He is going to come with his yacht which he has redecorated with Louis XV *chinoiserie* and porphyry tables. We are going to meet him in Barcelona and afterwards we shall return to Port Lligat in his boat, probably sitting at the porphyry tables. His stay will have a historical significance because we have to make a decision about the making of the enamelled gold chalice set with precious stones which is destined for the Tempietto di Bramante in Rome. So on August 2nd I shall describe his memorable visit with the care of a chronicler in the grand manner, of which I am perfectly capable if I choose.[13]

12. Dalí himself brought these two swans to Port Lligat and has succeeded in acclimatising them perfectly.

13. Alas! This time Dalí made a promise which he did not keep. His diary for August 2nd, 1952, is silent. But in 1953 we shall met Arturo Lopez again.

the 12th

I have had creative dreams all night. In one of them, I invented a complete dress collection, itself sufficient to assure my fortune as a *couturier* for at least seven seasons. By forgetting my dream I have lost this little treasure. I have barely been able to reconstruct two dresses that will be worn by Gala in New York this winter – but the last of the night's dreams was very powerful. It was all about a method to obtain a photographic Assumption, which I shall call an 'Ascension'. I shall utilise the process in America. Wide awake, I still find this dream as excellent as during sleep. Here is my recipe: you take five bags of chick peas which you put into a bigger bag that will hold them all; you drop the peas from a height of thirty-five feet; with a sufficiently powerful electric light you project on to the falling chick peas an image of the Virgin; each chick pea separated from the next by space, like the corpuscles of an atom, will register a small part of the image; next you project the image upside down; due to the acceleration resulting from the laws of gravity, the inverted fall of the chick peas will produce the effect of an 'Ascension'. If you follow these directions you will have an Ascensionist image that corresponds to the purest laws of physics. Needless to say, such an experiment will be unique of its kind. To heighten the effect, you might cover each chick pea with some substance that will give it the consistency of a movie screen.

the 13th

Today I wrote the following letter to Pla.:

Dear Friend,

L. left saying that a book by you about me would be enormously successful in Argentina and that it would be translated into several languages. Since I know you are writing many books at the moment, I think that it is the right moment to write one more. The important thing is to find a way to write without working at it, meaning that this book should write itself. I have solved this problem by means of the title: *Dalí's Atom*. The prologue will already exist in the form of this letter, in which we agree that at least in the region of Ampurdan,[14] the only atom being made is the Dalí atom, which will give the book all the interest it needs. So, while everybody else loses his way in side issues, you will concentrate on a single Dalí atom which will more than repay such study. Each time we meet I shall give you the latest news about my atom, as well as photographs and documents. In this way you will have to create only the atmosphere around it, which should be easy for you, given your exquisite descriptive gifts. My atom is so active that it works all the time. I repeat – it,

14. Region of the Costa Brava that includes Cadaqués and Port Lligat.

not we, will write the book. To an atom – and a Dalí atom especially – a book becomes a natural need. I shall go so far as to say that it rests while writing a book. A book devoted to something that I cannot describe in any precise way, as I do not yet know what it is about. Besides, to me, a paroxysist possessed by imperialist definitions, there is nothing in the world that looks so sweet, pleasant, restful, and even gracious as the transcendental irony implied by Eisenberg's principle of incertitude.

Come and have lunch with us. You will eat whatever you like or that suits your diet.

Yours,

the 14th

I dream of two knights. One is naked and so is the other. They are about to enter two absolutely symmetrical streets. Their horses, lifting the same leg, each enter their respective street, but one street is flooded with a light that is poignant with objectivity, while the other is limpid, as in Raphael's *Marriage Of The Virgin*, and in the distance is even more crystalline. Suddenly one of the streets is filled by a shifting mist which gradually thickens till it forms an impenetrable leaden abyss. Both knights are Dalí. One belongs to Gala, the other is the one who would not have known her.

the 15th

> *Don't bother about being modern. Unfortunately it is the one thing that,*
> *whatever you do, you cannot avoid.*
> SALVADOR DALÍ

Once more I thank Sigmund Freud and proclaim louder than ever his great truths. I, Dalí, deep in a constant introspection and a meticulous analysis of my smallest thoughts, have just discovered that, without realising it, I have painted nothing but rhinoceros horns all my life. At the age of ten, a grasshopper-child, I already said my prayers on all fours before a table made of rhinoceros horn. Yes, to me it was already a rhinoceros! I take another look at all my paintings and I am stupefied with the amount of rhinoceros my work contains. Even my

famous bread is already a rhino horn, delicately resting in a basket[15]. Now I understand my enthusiasm the day Arturo Lopez presented me with my famous rhinoceros-horn walking stick. As soon as I became its owner, it produced in me a completely irrational illusion. I attached myself to it with an incredible fetishism, amounting to obsession, to such an extent that I once struck a barber in New York, when by mistake he almost broke it by lowering too quickly the revolving chair on which I had gently put it down. Furiously, I struck at his shoulder hard with my stick to punish him, but of course I immediately gave him a very big tip so that he would not get angry.

Rhinoceros, rhinoceros, who are you?

the 16th

The uniform is essential in order to conquer. Throughout my life, the occasions are very rare when I have abased myself to civilian clothes. I am always dressed in the uniform of Dalí. Today I received an ageing young man who came to beg my advice before he undertakes a journey to America. The problem interests me. So I dress as Dalí and go down to meet him. His case is as follows: he wants to go to America and make a success of something, anything, so long as he succeeds. The mediocrity of life in America is too much for him. I ask him:

'Do you have fixed habits? Do you like to eat well?'

He answers greedily: 'I can live on anything! Dried beans and bread every day for years!'

'That's bad!' I tell him dreamily and with a preoccupied manner.

He is surprised. I explain to him: 'If you want to eat beans and bread every day, it will be very expensive. You must earn it by working very hard. On the other hand, if you can get used to living on caviar and champagne, it doesn't cost a thing.'

He smiles stupidly and thinks I am joking.

'I never made a joke in my life,' I exclaim with authority.

At once he starts listening humbly.

'Caviar and champagne are things that are offered you free by certain very distinguished ladies, wonderfully perfumed and surrounded by the most beautiful furniture in the world. But to get them, you must be quite different from the you who comes to see Dalí with dirty fingernails, while I have received you in uniform. Go and work on the problem of the dried beans. It's your problem. And besides, you have the prematurely wrinkled look of a dried bean. As for the spinach colour of your shirt – make no mistake, that is exactly what characterises failures and people who are old before their time.'

15. 'For six months,' Dalí says, 'my objective was to recover the technique of the old masters, to reach the immobility of a pre-explosive object. It is my most rigorous painting from the point of view of geometric preparation.'

the 17th

Don't be afraid of perfection. You will never attain it!
SALVADOR DALÍ

I possess within myself the constant awareness that everything which touches my person and my life is unique and will always be characterised by an exceptional, complete and truculent nature. While I am having breakfast, I see the sun rise and I realise that, since Port Lligat is geographically the eastern-most part of Spain, I am the first Spaniard to be touched by the sun each morning. Yes, even in Cadaqués, which is ten minutes from here, the sun appears later.

I am also thinking about the picturesque surnames of the fishermen of Port Lligat: the marquess; the minister; the African; there are even three Jesus Christs. I am sure that there are few places in the world – especially as small as this – where three Jesus Christs can meet each other.

the 18th

Quien madruga, Dios ayuda.[16]
SPANISH PROVERB

Even though my *Assumption* is making substantial and glorious progress, it frightens me to see that already it is the 18th of July. Every day time flies faster, and though I live from one ten minutes to the next, savouring them one by one and transforming the quarters of an hour into battles won, into feats and spiritual victories, all of which are equally memorable, the weeks run by and I struggle to cling with an even more vital completeness to each fragment of my precious and beloved time.

Suddenly Rosita comes in with breakfast and brings me a piece of news that throws me into a joyous ecstasy. Tomorrow will be the 19th of July, and that is the date on which Monsieur and Madame arrived from Paris last year. I give an hysterical yell:

'So I haven't arrived yet! I haven't arrived. Not before tomorrow will I come to Port Lligat. This time last year, I hadn't even started my Christ! And now before I've so much as come here, my *Assumption* is almost on its feet, pointing to heaven!'

I run straight to my studio and work till I am ready to drop, cheating and taking advantage of not being there yet so as to have as much as possible already done at the moment of my arrival. All Port Lligat has heard that I am

16. "God helps those who rise early."

not yet there, and in the evening, when I come down for supper, little Juan calls out, as gay as can be:

'Señor Dalí is coming tomorrow night! Señor Dalí is coming tomorrow night!'

And Gala looks at me with an expression of protective love which so far only Leonardo has been able to paint, and it so happens that the fifth centenary of Leonardo's birth is tomorrow.

In spite of all my stratagems to savour the last moments of my absence with an intoxicating intensity, here I am, finally home in Port Lligat. And so happy!

the 20th

Rosita provides me with more temporal happiness, reminding me that last year I started the Christ four days after my arrival. I let out a yell even more hysterical than that of the day before yesterday, so much so that the fishermen who were quite a long way out to sea in their boat raised their heads for a moment and looked at my house. I believed myself to be entirely in the grip of time and I find that I can escape from it for four more days, and I think that if I could only hear news like this every day, I could remount the river of time against the current. Be that as it may, I feel rejuvenated, and I feel devilishly more capable of successfully finishing my work, my *Assumption*.

the 21st

How can I ever doubt that everything that happens to me is highly exceptional? At five o'clock this afternoon, I was busy analysing some octagonal figures drawn by Leonardo da Vinci. In my opinion, they should royally govern the dogma of the Assumption. Suddenly, I lift my head to contemplate one of the most typical forms in my work: a giant, solemn and ascensional figure eight. I had only just noticed it. At that moment Rosita brings in the mail. Among the letters is one from the mayor of Elche, who is sending me the programme of the liturgical, lyrical, and even acrobatic mystery that will take place on August the 14th, for the first time since Eleusis. On one of the photographs can be seen the gold pomegranate descending, open, from the cupola. It contains the angels that will carry off the Virgin. Immediately I count: one, two, three, four, five, six, seven, and *eight*! The pomegranate is octagonal! And the hole in the centre of the cupola looks more or less like the one in my painting. When Arturo comes, I shall suggest a party of friends who are likely to be enraptured; and we shall all go to Elche together in the boat.

the 22nd

The Virgin does not ascend to heaven while praying. She ascends by the very

strength of her antiprotons. The dogma of the Assumption is a Nietzschean dogma. Far from holy weakness, as it is called in error and because of his own weakness by the great and admired philosopher Eugenio d'Ors, the Assumption is the paroxysm of the will to power of the eternal feminine, which Nietzsche's followers claimed to attain. Whereas Christ is not the superman He is believed to be, the Virgin is wholly the superwoman who, according to the dream of the five bags of chick peas, will fall to heaven. And this indicates that the mother of God remains body and soul in paradise thanks to her own weight being the same as that of God the Father in person. Exactly as Gala might have re-entered the house of my own father!

the 23rd

Three thousand elephant skulls!

A French colonel comes at dusk to pay me a visit. When we get around to the question of the elephant skull, I say to him:
'I have five already!'
'Why so many elephant skulls?' he exclaims.
'I need three thousand of them. For that matter, I'm going to have them! A friend of mine, a maharajah, is going to bring me a boatload, I hope. The fishermen will come to unload them right here, on the little jetty. I'll have them spread all over the place in the planetary geology of Port Lligat.'
'That will be beautiful, that will be Dantesque,' cries my colonel.
'Above all it is what will be most appropriate. You cannot plant a thing in this landscape without spoiling it. There must be no pine trees. The effect would be horrible. Elephant skulls are really what would be best.'

the 25th

It is Saint Jacques' Day, the feast day of Cadaqués. My tiny grand-mother, who is always so clean and neat, never failed to recite these verses on an occasion like this, when I was a child:

Saint Jacques' Day
Twenty-fifth Day
There was a great celebration
In the bullring
All the bulls were bad
And there was a reason
To burn the convents.

This poem seems to me to epitomise the utter inconsistency of being a Spaniard.
Tonight, we had sensed from the very long and solemn twilight that we

were about to have one of those cold, hollow summer nights. From the tent of some hikers, not far from the house, comes forth automatically the series of inevitable songs, beginning with *El Solitero De La Cardina*.

Those impromptu singers give me unexpected pleasure of an incomparably languorous and emotional intensity. Each song takes me back with sentimental and visual vividness to the summers of my adolescence when I myself went camping and sang with my friends. Really, those simple hikers have just given me a few wonderful moments. If I were omnipotent, I would order them to be punished with three or four strokes of a stick. Because they are not the way I used to be. I know they are stupid, sports-loving, and good. At their age, I took Nietzsche in my knapsack and I was already racking my own brains and those of others.

the 26th

If you are mediocre, even if you make a great effort to paint very very badly, people will still see you are mediocre.
SALVADOR DALÍ

After an exhausting day's work, I receive a telegram that confirms the arrival in Rome of the one hundred and two illustrations for the *Divine Comedy*. The publisher, Janes, brings me the book *The Naked Dalí*. We dine and drink a marvellous champagne which I sip in a paroxysm of enjoyment. These are the first two glasses of champagne I have drunk in eight years.

the 27th

This morning an exceptional defecation: two small turds in the shape of rhinoceros horns. Such a scanty stool worries me. I would have thought the champagne, so alien to my routine, would have had a laxative effect. But less than an hour later, I have to go back to the toilet, where I finally have a normal bowel movement. My two rhinoceros horns must have been the end of some other process. I shall return to this question of primordial interest.

the 28th

It has been raining all day on my elephant skull and also elsewhere. At siesta time there is a mild thunderclap. When I was little they used to tell me: 'Somebody is moving the furniture around on the floor above.' Nowadays I think of the need to protect the house with a lightning conductor. In the evening I discover in the kitchen a big earthenware pot full of snails. I had already been feasting my eyes on these damp delicacies during the day. All those grey spirals inside their shells seem to lie in a kind of starch that is the colour of lead, turgescent and silky. The grey shades eclipse the oysterish blacks, and the milky

whites remind one of the underside of a partridge.

the 29th

Piet:[17] less than a fart more than a flea of genius

Because of a very long fart, really a very long and, let us be frank, melodious fart, that I produced when I woke up, I was reminded of Michel de Montaigne. This author reports that Saint Augustine was a famous farter who succeeded in playing entire scores.[18]

the 30th

Great joy after believing the month was over today through erroneous information from the maid. I learn before dinner that tomorrow will only be the 31st. That means I shall have finished painting Gala's face in the *Assumption*, a portrait that will be the most beautiful and the best likeness of all I have done of my

rediviva and ascensionist!

17. Abstract painter that Dalí has been using as his scapegoat for years. Compare *The Cuckolds Of Old Modern Art*, published by Fasquelle.

18. Dalí is very much attached to a precious long-playing record of a session at a club of American petomanes, and he is always re-reading a precious little book, *The Art Of Farting*, by Count Trumpet.

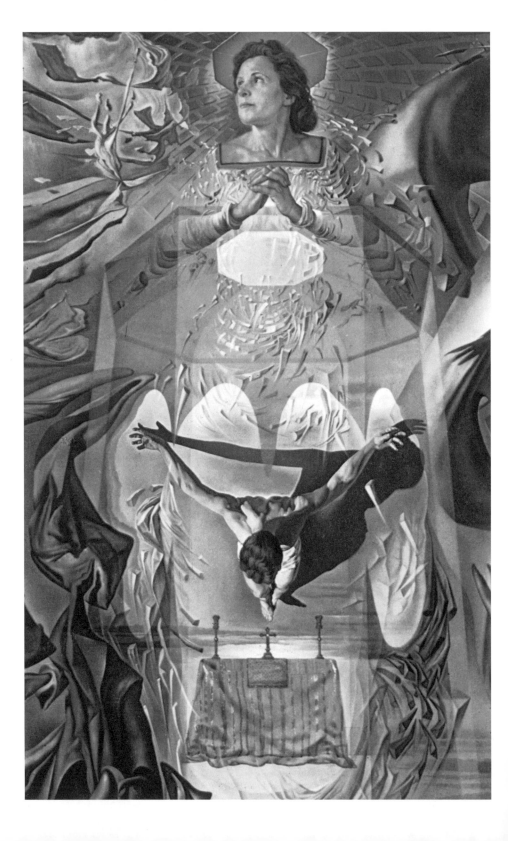

August

the 1st

Tonight, for the first time in at least a year, I am looking at the starry sky. It seems small. Am I getting bigger or is the universe shrinking? Or a combination of both? How different from the painful contemplation of the stars in my adolescence. They overwhelmed me because of what my romanticism made me believe at the time: the unfathomable and infinite cosmic immensity. I was possessed by melancholy because all my emotions were undefinable. Whereas now my emotion is so definable that I could make a cast of it. At the same time, I decide to order one in plaster that will represent with maximum accuracy the emotion prompted by the contemplation of the celestial vault.

I am grateful to modern science for corroborating by its researches that most pleasant, sybaritic, and anti-romantic notion that 'space is finite'. My emotion has the perfect shape of a four-buttock continuum, the tenderness of the very flesh of the universe. When I go to bed, dog-tired after my day's work, I try to preserve my emotion even in bed, feeling increasingly reassured and telling myself that, when all is said and done, the universe – expansible, even with all the matter it contains, however abundant it may seem – is nothing but a simple and straightforward matter of adding up marbles. I am so happy to see the cosmos finally reduced to these reasonable proportions that I might almost rub my hands if that abominable gesture were not typically anti-Dalí. Before going to sleep, instead of rubbing my hands I shall kiss them with the purest enjoyment, repeating to myself that the universe, like every material thing, looks petty and narrow if compared, for instance, with the breadth of a forehead painted by Raphael.

the 20th

They have finally delivered the plaster cast of my emotion and I decide to take a photograph of this four-buttock continuum. There are some friends down in the garden, and then a society woman climbs up to where I am. I look at her – I look at all women – and suddenly I have an insight: the person who is now before me, turning her back to me, has two of the very buttocks of my continuum. I beg her to come closer to the cast and I tell her that she has my vision of the universe at the bottom of her back. Would she consent to my taking a photograph? In the most natural manner she accepts, pulls up her dress, and while she leans over the little wall to chat with friends who are on the terrace below and have no idea what is going on, she offers me a view of her buttocks to enable me to compare the cast and the very flesh of that cast.

When I have finished she straightens her dress and hands me a magazine which she has been keeping in her bag for me. It is an old magazine, dirty and tattered, in which I find, with an intoxication that can be imagined, a reproduction of a geometric figure identical with my cast: a surface with a complete and constant curve obtained by experiments with the mechanical segmentation of a drop of oil.

So many typically Dalínian events in so short a time confirm my conclusion that I have reached the summit of my genius.

September

the 1st

The Assumption is an elevator. It ascends because of the weight of the dead Christ.

I am the first to be stupefied by the singular and extraordinary things that happen to me every day, but it must be said that the unique event of my life occurred this afternoon, after a restorative quarter of an hour's nap.

Trying to take down my *Assumption* in order to paint the upper parts and coming up against something that stopped the pulleys from functioning normally, I forced the mechanism and the canvas came unfastened, falling noisily into space, from a height of at least ten feet, into the trench into which I lower it or from which I raise it according to my needs. I feared that my painting would be scratched, probably even torn, and my three months' work wasted, or that at best I would be obliged to waste time in wearisome efforts at restoration. The screams I uttered brought the maid running, and she remarked that I was as pale as death! I could see my exhibition in New York postponed, or even cancelled. Someone had to be called to go down into the hole and bring up the ruins of my unfinished masterpiece. Unfortunately everyone in Port Lligat has his siesta at that time of day. In a frenzy I went up to the hotel. I lost an *espadrille* on the way which I did not even bother to pick up. I must have looked terrible with my hair and moustache in a mess. Seeing me come in, a young English girl screamed and ran to hide. Finally I found Raphael, the owner, and asked him to come and help me. As pale as I was, he went down into the trench and with extreme care we managed to bring the painting back up. A miracle! It was intact. Not a single scratch, not one speck of dirt! No one who has tried to reconstruct the event can understand how this could have been possible, if the intervention of angels[19] be excluded.

Then I suddenly realised that the falling of my painting had in one stroke gained me the whole month of August! Yes, I had been afraid to work on my painting because of its perfection, and I had been slowing down, hanging back. Now, having believed it to be destroyed, I would work fast and fearlessly. The remainder of the day was enough to draw the two feet, even to paint the right one and to finish the sphere that signifies the world. While I was working, I thought all the time of the Virgin falling towards the sky by force of her own weight. The same thing happened to me with my Virgin, who descended into the depths of her grave. I have succeeded in rendering her glorious Ascension materially, morally, and symbolically. This sort of miracle, I am sure, occurs in

19. Dalí has personal and particular relations with the angels.

this world because of one person only – Salvador Dalí, to name him. I humbly thank God and His angels.

the 2nd

The worst painter in the world, from every point of view, without the foggiest hesitation or any possible doubt, is named Turner.
SALVADOR DALÍ

Again this morning, while I was on the toilet, I had a truly remarkable piece of insight. My bowel movement, by the way, was perfectly exceptional this morning, smooth and odourless. I was thinking about the problem of human longevity, because of an octogenarian who works at this problem and who has just parachuted over the Seine, using a red-silk parachute. My intuition is that if it were possible to make human excrement as fluid as liquid honey, man's life would be extended, because excrement (according to Paracelsus) is the thread of life, and each interruption or fart is but a moment of life flying away. It is the equivalent in time of the Fates' snip of the scissors, who in the same way cut the thread of existence, divide it up and use it. Temporal immortality must be looked for in refuse, in excrement and nowhere else... And since man's highest mission on earth is to spiritualise everything, it is his excrement in particular that needs it most. As a result, I increasingly dislike all scatological jokes and all forms of frivolity on this subject. Indeed, I am dumbfounded at how little philosophical and metaphysical importance the human mind has attached to the vital subject of excrement. And how distressing it is to note that among so many lofty minds there are quite a few who give vent to their needs like everybody else. The day I write a general treatise on this subject, it is quite certain that I will astonish the whole world. For that matter, that treatise will be the exact opposite of Swift's essay on latrines.

the 3rd

Today is the anniversary of the Beistegui ball. The memory of that 3rd of September last year in Venice floods me with the keenest anguish, but I tell myself today that I must finish the left foot and begin the 'radiolorium',[20] the terrestrial globe of rhinocerontic anguish. In two days I shall begin to paint the 'niçoids'[21] in perspective. Then I shall indulge in the great luxury of an exhausting retrospective contemplation of the Beistegui ball. I shall need to do this in order to lose myself in the luminous and Venetian corpuscles of my Gala's glorious body.

20. The radioloria suggest in every detail the famous armillary spheres which figure notably on the arms of Portuguese kings.

21. The niçoids are the corpuscular elements that make up Dalí's *Corpuscularia Lapislazulina*.

the 4th

Several times I have to put up a valiant fight to keep the Beistegui ball from monopolising the viscous flow of my musings. I succeed in protecting myself against visions of the ball, in just the same way as I used to circle the table for a good hour when I was a child, dying of thirst before I took a glass of cold water, thereby deepening the chalice of my raving and unquenched thirst.

the 5th

I continue to hold back my memory of the Beistegui ball, just as one holds back one's urine, and I jump around and at the same time invent a new choreography before my painting. I am also holding back my 'niçoids'.

the 6th

At the very moment that I was finally going to let my cherished and beloved Salvadorian brain begin recollecting the Beistegui ball, a lawyer was announced. I had it politely explained to him that I was working and would be able to see him at eight o'clock. But to set a limit to my planned contemplation induces a feeling of revolt in me. And then the maid comes back telling me that the lawyer insists on seeing me because he has come in a taxi. This reason seems very stupid to me because taxis are not like trains – they can wait. I repeat to Rosita that my contemplation and the corpuscles of Gala's glorious body cannot be disturbed before eight o'clock in the evening. But the lawyer, pretending to be a great friend of mine, enters the library, pushes aside some extremely rare art books, upsets my mathematical calculations, my original drawings which are so precious that nobody is allowed to touch them, and begins to draw up a sworn statement which asserts that I have refused to see him. Then he asks the maid to sign it. She refuses, suspects the whole business, and comes up to warn me about the situation. I dash down, tear up all the papers he has dared spread out on the table,[22] whereupon I throw this lawyer out of the house with a kick up the behind, a wholly symbolical kick because I did not even touch him.

the 7th

I indulge in a state of ecstatic pre-reverie which paves the way for the Beistegui ball. Already I sense the Proustian correspondence between Port Lligat and Venice. At six o'clock, I observe the projection of a shadow up in the mountains where there is a tower. It seems to me to be perfectly synchronised with the shadow that lengthens the lateral windows of the Church of La Salute on the

22. Dalí realised later that he had torn up the lawyer's 'matrix', an act as original as sin, an outrage on the law.

Grand Canal. Everything is tinged with the same pink as on the day of the ball at about six o'clock in the vicinity of the customs house.

Tomorrow, for sure, I shall begin my 'niçoids' and I shall indulge in my contemplation of the Beistegui ball.

the 8th

I have done it! I have begun the 'niçoids', sublime with supplementary colours that amount to a paroxysm. There are green ones, orange ones, and salmon-pink ones. Here they are at last, my beautiful corpuscular 'niçoids'. But I am enjoying myself too much, and I push back thoughts of the Beistegui ball till the next day. In the morning I shall do some 'niçoids' without dreaming, in complete liberty of thought, but in the afternoon I will give myself up to dreaming about the ball with an obsession for truculent precision. I shall utterly exhaust my languid memories, till I am drained dry.

the 9th

Today I would certainly have given free rein to my thoughts about the Beistegui ball if I had not been disturbed by a police summons to appear on the 11th. It is the result of the incident with the lawyer, and they tell me it may mean twelve months in prison. I postpone my reflections till later and go speeding in the Cadillac to G. to see Ambassador M., whom I ask for advice. He behaves both very affectionately and very respectfully towards me, and we telephone at least two ministers.

the 10th, 11th, 12th, 13th, and 14th

In order not to be disturbed we listen to an official document being read one afternoon. I have wasted all these days attending to the problem of the lawyer! From now on I shall behave with the conventionality of a supersonic louse towards all such officials, public or otherwise. Anyway this has always been my point of view. If I acted differently on this particular occasion, it was because my sublime 'niçoids' inspired me, as a dog is inspired by his bone. No, it was much more than this. My inspiration was of a cosmic order, and it is obvious that a lawyer cannot begin to understand this. What I was feeling at the moment I was interrupted was the approach of the corpuscular outlines of ecstasy.

the 15th

The anguish caused by the possibility of twelve months in prison, as a result of the incident with the lawyer, provokes in me a sharp sense of instantaneity. I adore Gala even more than I could have known. I have started painting as a nightingale sings. Suddenly my canary lets out a trill – which is strange because

it had given up singing. Little Juan sleeps in our room. He is a true mixture of Murillo and Raphael. I had done three drawings in red chalk of Gala praying in the nude. The last three days we have been burning a fire in the big fireplace in our room. When we turn off the light the burning logs illuminate us! It feels fine not to be in prison yet, so splendid that I am giving myself a day's vacation tomorrow, before indulging in the great, exhausting, supreme, delicious reverie of the Beistegui ball. I have finished the Virgin's hands and arms.

the 16th

I have started on the first corpuscles of my *Assumption*. For the time being, no prison, and it makes me savour to the point of paroxysm the voluntary prison of my house at Port Lligat. I am spiritually preparing myself to begin tomorrow, at the stroke of half past three, my reverie of the Beistegui ball.

the 17th

But it wasn't to be! The reverie of the Beistegui ball has not taken place. I have begun to realise that from this difficulty in beginning a reverie which already provides me with so much pleasure beforehand – and just thinking about it – stems something typically Dalínian and paradoxical, something that is also truly unique. Because I have the impression of a slight pain in the liver which I attribute to the anxiety caused by the incident of the lawyer; but in the end I discover that I simply have a coated tongue. This has not happened to me for so many years that it surprises me very much. So in the end I take half a normal dose of purgative. This purgative is exceedingly smooth. I doubt now that the reflections will take place tomorrow. Nevertheless, the vague idea that I was not in a 'condition' to begin my great, hallucinatory and beloved reverie might be explained by my very unusual coated tongue. To have an upset stomach is quite incompatible with the supreme euphoria that must physiologically precede any intense and ecstatic act of imagination.

Gala has come in and kissed me before I go to sleep. It is the sweetest and best kiss of my life.

November

Port Lligat, the 1st

The moment somebody very important or even semi-important dies, it gives me a feeling, which is at once intense, monstrous and reassuring, that this dead person has become 100 per cent Dalínian because from now on he will watch over the fulfilment of my work.

SALVADOR DALÍ

This is the day to think of the dead and of myself. The day to think about the death of Federico Garcia Lorca, shot in Granada, about the suicide of René Crevel in Paris, and of Jean-Michel Franck, in New York. About the death of surrealism. Of Prince Mdivani, guillotined by his Rolls-Royce. About the deaths of Princess Mdivani and of Sigmund Freud, exiled in London. About the double suicide of Stefan Zweig and his wife. About the death of Princess de Faucigny-Lucinge. About the deaths in the theatre of Christian Bérard and Louis Jouvet. About the deaths of Gertrude Stein and of José-Maria Sert. About the deaths of Missia Sert and of Lady Mendel. Of Robert Desnos and Antonin Artaud. Of existentialism. About the death of my father. The death of Paul Eluard.

I know for a fact that my qualities as an analyst and psychologist are superior to those of Marcel Proust. Not only because, among the many methods he did not know about, I use that of psychoanalysis, but especially because of the structure of my mind, which is of an eminently paranoid type, particularly qualifying me for this sort of exercise; whereas the structure of Proust's was that of a neurotic depressive, and therefore least suited to such investigations. This is easily recognised from the depressing and distracted look of his moustache, which, like Nietzsche's, which is even more depressing, is the exact opposite of the alert and gay bacchantes of Velasquez or, better still, of the ultra-rhinocerontic moustaches of your humble servant and genius.

It is true that I have always liked using the pilose system, either from the aesthetic point of view in order to determine the ideal equilibrium which depends on the spacing of the hair, or in the psychopathological domain of the moustache, that tragic constant of the character, definitely the most truculent feature of the male physiognomy. It is even truer that if I prefer to use gastronomic terms to impose my philosophical ideas, which are difficult and laborious to digest, I always want those ideas to have a savage transparency, down to the very last hair. I would never tolerate a lack of clarity, however slight it might be.

Which is why I like to say that Marcel Proust, with his masochistic introspection and his anal and sadistic dissection of society, has succeeded in concocting a kind of prodigious shrimp bisque, impressionistic, super-sensitive,

and quasi-musical. The only thing missing are the shrimps, of which it might be said that they are present only in essence. Whereas Salvador Dalí, by contrast, as a result of all the most imponderable essences and quintessences of his own dissection, and of those of others which are never the same, succeeds in offering you on a dazzling plate and without a hair of knowledge, nothing less than a real shrimp, swimming, concrete, gleaming and jointed like the truly edible armour of reality which in fact it is.

Proust makes music out of a shrimp; Dalí, on the other hand, succeeds in making a shrimp out of music.

But let us talk about the death of those contemporaries that I have known and that have been my friends. My first, reassuring feeling is that they become so Dalínian that they will function at the sources of my work. At the same time, a different feeling manifests itself, disquieting and paradoxical: I believe myself to be the cause of their death!

Without having to ask for them, I obtain the most comprehensive proofs of my criminal responsibility from my lunatic paranoid interpretation. But since, from an objective point of view, this is wholly false, and since, too, I float above it all because of my almost superhuman intelligence, everything comes out all right. And that is why I can confess to you, with melancholy but without any shame, that the successive deaths of each of my friends superimposing themselves in very thin layers of 'false guilt feelings' ultimately constitute a kind of soft pillow on which I go to sleep at night, fresher and less anxious than ever.

Shot to death in Granada, the poet of villainous death, Federico Garcia Lorca!
Olé!
With this typically Spanish exclamation, I received in Paris the news of the death of Lorca, the best friend of my turbulent adolescence.

That exclamation, biologically uttered by the lover of bullfights each time the matador succeeds in making a beautiful 'pass', or by the audience encouraging flamenco singers, was made by me on the occasion of Lorca's death, showing in this way how his destiny was fulfilled by tragic and typically Spanish success.

At least five times a day, Lorca alluded to his death. At night, he could not go to sleep unless several of us 'put him to bed'. Finally, in bed, he would still find ways to prolong endlessly the most transcendental conversations about poetry that this century has ever known. Nearly always, he ended by discussing death, and especially his own death.

Lorca gestured and sang all he spoke about, notably his demise. He acted it all out. 'Look,' he would say, 'what I'll be like the moment I die!' Upon which he would dance a sort of horizontal ballet that represented the broken movements of his body during burial, when the coffin would go down a certain steep incline in Granada. Then he would go on to show us how his face would look a few days after his death. And his features which were normally not very

handsome suddenly radiated a new beauty and even took on an extreme loveliness. Whereupon, sure of the effect he had had on us, he would smile, radiant with the triumph of an absolute lyrical possession of his spectators.

He wrote:

El rio Guadalquivir tiene las barbas grentaes
Grenada tiene doa rios, uno llanto, el otro sangre.[23]

Moreover, at the end of the (doubly immortal) ode to Salvador Dalí, Lorca alludes in an unequivocal manner to his own death and asks me not to linger over it as long as my life and my work go on flourishing.

The last time I saw Lorca was in Barcelona, two months before the Civil War. Gala, who did not know him, was deeply impressed by this viscous phenomenon of complete lyricism. Indeed this sentiment was reciprocal: for three days Lorca, greatly impressed, spoke only of Gala. Edward James, too, the immensely rich poet, as hyper-sensitive as a humming-bird, was captured and immobilised in the birdlime of Federico's personality. James dressed in a Tyrolean outfit with too much embroidery, leather shorts, and a shirt trimmed with lace. Of him Lorca said that he was a humming-bird dressed up like a soldier of Swift's day.

During our meal at the restaurant of the Canary of the Garriga, a tiny, extraordinarily well-dressed insect walked across the tablecloth doing the goose step. Lorca recognised it immediately and cried out, but hid its identity from James by pressing the bug down with his finger. When he withdrew his finger, there was no trace of the insect. Now that little bug, a poet too, and dressed in Tyrolean lace, might have been the one thing to change Lorca's destiny.

As a matter of fact, James had just rented the Villa Cimbrone, near Amalfi, which had inspired Wagner to create *Parsifal*. He invited Lorca and me to go and stay there, as long as we liked. For three days my friend was in a quandary: should he go or should he not? Every quarter of an hour he changed his mind. In Granada, his father, who suffered from a heart condition, was afraid he was going to die. In the end Lorca promised that he would join us as soon as he had visited his father to reassure himself. In the meantime the Civil War broke out. He was shot, whereas his father is still alive.

William Tell? I am still convinced that if we had not succeeded in bringing Federico with us, his temperament, which was psycho-pathologically anxious and indecisive, would have prevented him from ever joining us at the Villa Cimbrone. All the same, it was at that moment that a grave feeling of guilt about him was born inside me. I had not tried hard enough to tear him away from Spain. If I had really wanted to, I could have taken him to Italy. But at the time, I was writing a great lyrical poem, *I Eat Gala*, and I felt more or less consciously jealous of Lorca. I wanted to be alone in Italy, overlooking the

23. "The river Guadalquivir has a garnet beard, Granada has two rivers, one of tears, one of blood."

terraces of cypresses and orange trees, the solemn temples of Paestrum, which, by the way, in order to satisfy my megalomaniac happiness and thirst for solitude, I was lucky and happy enough not to like at all. Yes, at the time of Dalí's discovery of Italy, my relations with Lorca and our violent correspondence by a strange coincidence resembled the famous quarrel between Nietzsche and Wagner. It was also the period when I drew up the apology for Millet's *Angelus* and when I wrote my best book (which has not yet been published), *The Tragic Myth Of Millet's Angelus*,[24] and my best ballet, never produced as yet, called *Millet's Angelus*, for which I wanted to use Bizet's *l'Arlésienne* score, as well as some unpublished music of Nietzsche's. Nietzsche wrote his score while he was verging on madness, during one of his anti-Wagner fits. Count Etienne de Beaumont had discovered it, I believe, in a library at Basel, and though I had never heard it, I was sure that it was the only music that would suit my work.

The reds, the semi-reds, the pinks, and even the pale pinks all sought to benefit from shameful and demagogic propaganda on the death of Lorca, by the use of vile blackmail. They tried, and still try today, to make him into a political hero. But I, who was his best friend, can bear witness before God and before history that Lorca, 100 per cent a poet, was consubstantially the most apostolic human being I have ever known. He was simply the propitiatory victim of personal, ultra-personal, local matters, and above all the innocent prey of the convulsive, omnipotent and cosmic confusion of the Spanish Civil War.

However, one thing is certain. Each time that, out of my solitude, a brilliant idea springs from my brain, or I succeed in making a brush stroke that is archangelically miraculous, I always hear the raucous, slightly muffled voice of Lorca who calls out to me: Olé!

The death of René Crevel is a different story. To begin at the beginning, I must give a short outline of the history of the A.E.A.R. – the Association des Ecrivains et Artistes Révolutionnaires – a series of words which has the virtue of meaning just about nothing. The Surrealists who were at that time animated by a great idealistic generosity, and seduced by the equivocal character of the group's title, had joined it en bloc and made up the majority of this association of mediocre bureaucrats. Like all associations of this type, destined to go down to nothingness and doomed by congenital emptiness, the first concern of the A.E.A.R. was to convene a 'Great International Congress'. Even though the aim of such a congress was easy to foresee, I was the only one to denounce it in advance. In the first place, all writers and artists who subscribed to any values whatever were to be liquidated, and first and foremost all those who might possess or maintain the least truly subversive – and thus revolutionary – idea. Congresses are strange monsters surrounded in essence by corridors through which flow people who are physiologically appropriate to this movement. Now

24. Finally published by J.-J. Pauvert in 1963.

whatever you may think of Breton, he is above all a man of integrity and as rigid as a St. Andrew's cross. In any corridors, in any backstage manipulations, and especially in those of a congress, he quickly becomes the most obstructive and the least assimilable of all 'foreign bodies'. He can neither flow nor stick to the walls. This was one of the main reasons why the Surrealist crusade never even entered the door of the congress of the Association of Revolutionary Artists and Writers, as I had very shrewdly predicted without any sort of cerebral effort.

The only member of the group who believed in the effectiveness of the Surrealist participation in the International Congress of the A.E.A.R. was René Crevel. Now here we come to one extraordinary detail, full of significance: Crevel had not chosen to be called Paul or André like everybody else, nor even Salvador, like me. Just as, in Catalan, Gaudí[25] and Dalí mean 'enjoy' and 'desire', Crevel was called René, which could very well come from the past participle of the verb *renaître*, 'to be reborn'. At the same time, he had kept Crevel as his surname, which suggested the act of *se crever*, to die, or as the philologist-philosophers would say, the 'vital urge to die'. René was the only who believed in the possibilities of the A.E.A.R., which he made into his hobby-horse and of which he became a fervent advocate. He was endowed with the morphology of an embryo, or more precisely still, with the morphology of the bud of a fern just before opening, when it is getting ready to unroll the spirals of its nascent helices. You must have observed the gruff-looking face, like that of a bad angel, deaf and Beethovenian, in the curl of a fern bud. If you haven't thought of it yet, do so now, carefully, and you will know exactly what the puffy, backward baby face of dear René Crevel looked like. At the time he represented for me the most vital symbol of embryology, but today he too has changed in my eyes into the perfect example of the brand-new science entitled *phoenixology*, of which I shall speak to all of you who are lucky enough to be reading me. It is probably that you don't know anything about it yet, unfortunately. Phoenixology teaches us living beings the marvellous chances we have to become immortal in the course of this very terrestrial life – and this as a result of the secret possibilities we possess of rediscovering our embryonic state and thus being able to be perpetually reborn from our own ashes, like the Phoenix, the mythical bird whose name has been used to baptise this new science which claims to be the most special of all the special sciences of our age.

Nobody has so often 'perished' ('*crevé*'), nobody has so often been 'reborn' ('*rené*') as our René Crevel. His life consisted in one session after another of sanatoria. He would go in just about finished, and came out again flourishing – new, shiny and euphoric as a baby. But this did not last long. The frenzy of self-destruction soon got hold of him again and he began once more to worry, to smoke opium, to debate insoluble problems of an ideological, moral, aesthetic and emotional order, indulging in endless insomnia and tears

25. The architect, inventor of Mediterranean Gothic, designer in Barcelona of the uncompleted church of La Sagrada Familia, of a public garden, and of many residential buildings.

till he was 'dying all over again'. Then, like a man obsessed, he looked at himself in all the mirrors for manic impulsives to be found in the depressing and Proustian Paris of those days, each time telling himself: 'I look like death, I really do,' till, at the end of his strength, he would go and announce to some intimates: 'I'd rather die than go on another day like this.' He was sent to a sanatorium to be disintoxicated, and after months of assiduous care, René was reborn. We saw him reappear in Paris, overflowing with life like a happy child, dressed like a superior gigolo, gleaming, wavy-haired, already dying from an optimism that was given free rein in revolutionary generosities, and then, once more, gradually but ineluctably, beginning to smoke again, to torture himself again, curling and shrivelling up like a fern leaf unable to sustain itself.

René spent his steadiest periods of euphoria and of '*décrevelage*' (undying) in Port Lligat, this place worthy of Homer which belongs only to Gala and to me. They were the most beautiful months of his life, as he himself wrote in his letters. Those stays prolonged his life as long as he stayed. My asceticism impressed him, and all the time he lived with us at Port Lligat he lived like a hermit, following my example. He got up before me, before the sun, and spent his days completely naked in the olive grove, his face turned to the sky that is the hardest and most lapis lazulian in the whole Mediterranean, the most meridionally extremist in a Spain that is extremist to the point of death. He loved me above all others, but he still preferred Gala, whom he called the olive, as I did, repeating that if he did not find a Gala, an olive, for himself, his life could only end tragically. It was in Port Lligat that René wrote: *Les Pieds Dans Le Plat*, *Le Clavecin De Diderot*, and *Dalí Et l'Antiobscurantisme*.[26] Recently, Gala, recalling him and comparing him to some of our young contemporaries, exclaimed pensively: 'They don't make boys like that any more.'

So once upon a time there was a thing called A.E.A.R. Crevel began to wear an alarmingly unhealthy look. He thought he could not find anything better than the Congress of the Revolutionary Writers and Artists in order to indulge all the aphrodisiac and exhausting excesses of his ideological torments and contradictions. As a Surrealist, he honestly believed without making any concessions we could fall in with the Communists. However, long before the opening of the congress, the lowest intrigues and worst kind of manipulations took place so as to ensure straight away the liquidation of the ideological platform on which our group was established. Crevel ran back and forth between the Communists and the Surrealists, seeking exhausting and desperate reconciliations, constantly dying and being reborn. Every evening brought a drama and a hope. The most terrible crisis was the irreparable breach with Breton. Crevel, in tears, came to tell me about it. I did not encourage him in the Communist direction. Indeed I applied myself, following my habitual Dalínian tactics, to provoking, in each situation, the greatest possible number of insoluble antagonisms, so as to extract from all these opportunities the

26. *Feet In The Dish*, *Diderot's Harpsichord*, and *Dalí And Anti-Obscurantism*.

maximum of irrational juice. It was at this moment that my 'William Tell – piano – Lenin' obsession yielded to that of the 'great edible paranoiac' – I mean Adolf Hitler. To the sobs of Crevel, I answered that the only practical and possible conclusion of the A.E.A.R. congress would be to end up by adopting a motion that declared Hitler's face and chubby back to be endowed with an irresistible poetic lyricism, which should present no obstacle to fighting against him on the political level, rather the contrary. At the same time, I imparted to Crevel my doubts on the subject of the canon of Polycletus,[27] and drew the conclusion that I was almost certain Polycletus was a Fascist. René went away crushed. Because he had had daily proofs of it during his stays at Port Lligat, Crevel was surest of all my friends that at the bottom of my most truculent follies there always remained, as Raimu used to say, a basis of truth. A week went by, and I felt overcome by a sharp feeling of guilt. I knew I should telephone Crevel, otherwise he would think I was in agreement with Breton's attitude, even though the latter was as far from sharing my Hitlerian lyricism as the congress itself. In the course of that week of waiting, the behind-the-scenes intrigues at the congress led to Breton being forbidden even to read the report of the Surrealist group. In his place, Paul Eluard was allowed to present a version of it that had been much diluted and minimised. After those days, Crevel must have been constantly torn between the duties of the party and the exigencies of the Surrealist group. When I finally decided to call, a strange voice answered at the other end with olympian disdain: 'If you are any friend of Crevel's' – I was told – 'take a taxi and come at once. He is dying. He has tried to kill himself.'

I jumped into a taxi, but as soon as we reached the street where he lived, I was astonished to see a crowd standing round. A fire engine was parked in front of his house. I did not understand what connection there could be between the fire department and the suicide, thinking in typical Dalínian association that a fire and a suicide had both occurred in the same house. I made my way to Crevel's room, which was full of firemen. With the gluttony of an infant, René was sucking oxygen. I have never seen anybody so attached to existence. After having killed himself on Paris gas, he was trying to be born again on Port Lligat oxygen. Before killing himself he had attached a card to his left wrist on which he had written in clear capital letters: RENÉ CREVEL. As I wasn't too sure how to use the telephone at the time, I ran all the way to the Viscount and Viscountess de Noailles, great friends of Crevel's, where I could announce with as much tact as possible and in the most adequate manner the news which would upset Paris and which I had been the first to learn. In the drawing-room, glittering with gilded bronzes against the black and olive-green background of the Goyas, Marie-Laure pronounced some excessively windy words about Crevel which were immediately forgotten. Jean-Michel Franck, who was also to commit suicide a little later, was most touched by this death,

27. Greek sculptor of the fifth century B.C.

and had several nervous breakdowns during the next few days. The evening of Crevel's death, we strolled out on to the boulevards to see a Frankenstein movie. Like all films I see, obedient to my paranoiac-critical system, this one illustrated down to the smallest necrophilic detail Crevel's obsession with death. Frankenstein's monster even resembled him physically. Moreover the whole scenario was based on the idea of dying and being reborn, as a pseudoscientific foretaste of our new phoenixology.

The mechanical realities of war were to sweep away all such ideological torments. Crevel was like those tendrils of a fern which can unroll only on the edge of transparent, tormented and Leonardesque whirlpools of ideological fishponds. Since Crevel, nobody has seriously discussed dialectical materialism any more, or mechanical materialism, or anything else. But Dalí announces here and now that in the days to come, when the mind will have rediscovered its shapeliest ornaments, the words monarchy, mysticism, morphology and nuclear phoenixology will again stir the world.

René Crevel, I call to you: Crevel, be reborn. And you, in the Spanish manner and in Castilian, will reply: '*Présent!*'

Once upon a time there was a thing called the A.E.A.R.!

1953

May

Port Lligat, the 1st

I spent the winter in New York as usual, enjoying enormous success in everything I did. We have been in Port Lligat a month, and today, on the same date as last year, I decide to resume my diary. I inaugurate the Dalínian May the first by working frenetically, as I am urged to do by a sweet creative anguish. My moustache has never been so long. My entire body is encased in my clothing. Only my moustache shows.

the 2nd

I think that the sweetest freedom on earth for a man consists in being able to live, if he likes, without having the need to work.

I drew from sunrise till night: six mathematical faces of angels, of such great and explosive beauty that it left me exhausted and stiff. When I went to bed I was reminded of Leonardo comparing death after a full life to the coming of sleep after a long day's work.

the 3rd

In the course of my work I have infinite dreams about phoenixology. I was just being reborn for the third time when I heard over the radio an invention from the Lépine Congress. It seems they have found a means of changing the colour of hair without running the usual risks of dyeing it. A microscopic powder charged with an electricity opposite in kind to that of the hair causes an alteration in colour. If need be, I could keep my hair the most beautiful black while waiting for the realisation of my 'phoenixological' utopias. This assurance has afforded me the most vivid, childish joy, especially this spring when I feel rejuvenated in every respect.

the 4th

On the way into Cadaqués, Gala found a sheep-pen. She would like to convert it, and has spoken to the shepherd about buying it.

the 5th

As an epigraph to my book on craftsmanship,[1] I wrote: 'Van Gogh cut off his ear; before cutting off yours, read this book.' Read this diary.

the 6th

Everything can be done badly or well. It is the same with my painting!

the 7th

Let it be known that the most astonishing vision your brain could imagine can be painted with the artisan talent of a Leonardo or a Vermeer.

the 8th

Painter, you are an orator! So paint and keep quiet!

the 9th

If you refuse to study anatomy, the arts of drawing and perspective, the mathematics of aesthetics, and the science of colour, let me tell you that this more a sign of laziness than genius.

the 10th

A plague on lazy masterpieces!

the 11th

Begin by drawing and painting like the old masters. After that, do as you see fit – you will always be respected.

the 12th

The jealousy of other painters has always been the thermometer of my success.

1. *50 Secrets Of Magic Craftsmanship*, by Salvador Dalí, 1948, New York.

the 13th

Painters, be rich rather than poor. And to this end, follow my advice.

the 14th

Honestly ... do not paint dishonestly!

the 15th

Henry Moore, he is an Englishman!

the 16th

Braque – as in the case of Voltaire and the Lord – we nod to each other, but we do not speak!

the 17th

Matisse: the triumph of bourgeois taste and promiscuity.

the 18th

Piero della Francesca: the triumph of absolute monarchy and of chastity.

the 19th

Breton: so very much intransigence for such a small transgression!

the 20th

Aragon: so much *arrivisme*, and so little arriving!

the 21st

Eluard: so much confusion to stay so pure.

the 22nd

René Crevel: with Bonapartist Trotskyism, he will renecrevel himself.

the 23rd

Kandinsky? There is no escaping it: there can never be a Russian painter.

Kandinsky might have made marvellous *cloisonné* enamel cane heads, like the one I carry which Gala gave me for Christmas.

the 24th

Pollock: the 'Marseillais' of the abstract. He is the romantic of festivities and fireworks, like the first sensual tachist, Monticelli. He is not so bad as Turner. Because he is even more of a nobody.

the 25th

The popularity of African, Lapp, Breton, Latvian, Majorcan or Cretan art is nothing but modern cretinism. It is just Chinese, and God knows I have no love for Chinese art!

the 26th

From my earliest childhood, I have had the vicious turn of mind to consider myself different from ordinary mortals. In this, too, I am being successful.

the 27th

First: Gala and Dalí
Second: Dalí
Third: all the others, including, of course, the two of us once again.

the 28th

the 29th

the 30th

The worst moment is over for Meissonier.

June

the 1st

I discovered a week ago that with everything in my life, films included, I am about twelve years behind. For instance, for eleven years now I have been meaning to make a film that would be wholly, utterly, 100 per cent hyper-Dalínian. According to my reckoning, it is therefore probable that this film will finally be shot next year.

I am exactly the opposite of the hero of la Fontaine's fable *The Shepherd And The Wolf*. For in my life, and even during my adolescence, I have achieved so many sensational things, and it now happens that whatever I announce – as, for example, my liturgical bullfight, where courageous priests will have to dance in front of a bull that will be borne to heaven by a helicopter after the fight – everybody except me believes in the project which however – and this is the most surprising part – will end up, as sure as fate, by becoming a reality.

At the age of twenty-seven, for my arrival in Paris, I made two films in collaboration with Luis Buñuel which will remain historic – *Un Chien Andalou* and *L'Age D'Or*. Since that date, Buñuel has worked alone and directed other films, thereby rendering me the inestimable service of revealing to the public who it was who was responsible for the genius and who for the elementary aspects of *Un Chien Andalou* and *L'Age D'Or*.

If I create my film, I want to be sure that it will be, from beginning to end, a succession of wonders, because there is no point in bothering to see shows that are not sensational. The more numerous my public, the greater the fortune my film will bring its author, who has so justly been baptised 'Avida Dollars'. But for a film to seem marvellous to its audience, the first indispensable requisite is that the audience can believe in the marvels that are revealed to them. One must therefore abandon, first of all, today's repulsive cinematographic rhythm, that conventional and boring rhetoric of camera movements. How can one believe for a second in even the most banal melodrama when the camera follows the murderer everywhere, travelling even into the washroom where he goes to wash the blood off his hands? That is why Salvador Dalí, before he so much as begins his film, will take care to immobilise his camera, to nail it to the floor like Christ to the cross. Too bad if the action moves out of the visual field! The public will wait – distressed, exasperated, breathing heavily, stamping their feet, in ecstasy or, better still, bored to death – for the action to come back into the visual field. Unless some very beautiful and completely unrelated images distract the audience by parading before the immobile, bound, hyperstatic eye of the Dalínian camera, which will then

finally be restored to its true purpose of being slave to my prodigious imagination.

My next film will be exactly the opposite of an experimental *avant-garde* film, and especially of what is nowadays called 'creative', which means nothing but a servile subordination to all the commonplaces of our wretched modern art. I shall tell the true story of a paranoid woman in love with a wheelbarrow which successively takes on all the attributes of the beloved whose dead body has served as a means of transport. In the end, the wheelbarrow is reincarnated and becomes flesh. That is why my film will be called *The Flesh Wheelbarrow*. Sophisticated or ordinary, all the audience will be forced to participate in my fetishist delirium, because it is something that is strictly true and that will be told in a way no documentary could have managed. In spite of its categorical realism, my work will contain some really extraordinary scenes, and I cannot resist communicating some of them to my readers in advance, for the sole purpose of making their mouths water. They will see five white swans explode one after the other in a series of minutely slow images that develop according to the most rigorous archangelic eurythmics. The swans will be stuffed with real pomegranates that have been filled in advance with explosives, so that it will be possible to observe with all due precision the explosion of the birds' entrails and the fan-shaped burst of pomegranate seeds which will hit the cloud of feathers as one might imagine the corpuscles of light bump into each other, so that, in my experiment, the seeds will have the same realism as in the paintings of Mantegna, and the feathers the flowing vagueness which made the painter Eugène Carrière famous[2]. In my film there will also be a scene representing the Trevi fountain in Rome. The windows of the houses round the square will open, and six rhinoceroses will fall into the water one after the other. After each rhinoceros falls, a black umbrella will rise open, from the bottom of the fountain.

In another scene, the Place de la Concorde will be shown at daybreak, slowly being traversed in all directions by two thousand priests on bicycles carrying placards with the very vague but still recognisable effigy of Malenkov. And then, at the right moment, I shall show one hundred Spanish gypsies killing and cutting up an elephant in a Madrid street. They will leave only its fleshless skeleton, in this way transposing an African scene that I once read about in a book. At the point that the pachyderm's ribs become visible, two of the gypsies who, in spite of their savage frenzy, do not for one moment stop singing flamenco, will penetrate the carcass to appropriate the best giblets, the heart, the kidneys, etc. They will begin fighting over them with knives, while those who stayed outside will continue cutting the elephant into pieces, occasionally wounding the fighters inside, who with a horrible, piercing joy stuff the animal's interior, now transformed into a great bloody cage.

2. Eugène Carrière: French painter (1849–1906) and lithographer, known as *le Larousse*, born in Gournay. His figures are set against a misty background.

Nor should I forget a singing scene in which Nietzsche, Freud, Ludwig II of Bavaria, and Karl Marx will sing their doctrines with incomparable virtuosity, answering each other antiphonally, to some music by Bizet. This scene will unfold on the banks of Lake Vilabertran, in the middle of which, shivering with cold, the water up to her waist, a very old woman, dressed as a torero, will be balancing an *omelette aux fines herbes* on her shaven head. Each time the omelette slides off and falls into the water, a Portuguese will replace it for her with a fresh one.

Towards the end of the film, we shall see the globe of a candelabra that alternately swells and shrinks, then is covered with ornaments, then fades, burns bright again, turns liquid, hardens anew, etc... I have been thinking for almost a year about this summary of the entire political history of materialist humanity, symbolised by the morphological transformations of a marsh-mallow, simple and recognisable in the outline of the candelabra's globe. That long and very precise study lasts exactly one minute in my film and corresponds to the vision of a man overwhelmed by the sun, closing his eyes and painfully pressing them against the palms of his hands.

All this I alone can achieve – being, of course, inimitable – because I am the unique being, with Gala, who possesses the secret which enables me to create my film without ever having to cut or use montage. That secret alone will bring endless queues to the doors of cinemas where my work will be shown. Because, contrary to the expectations of the naïve, *The Flesh Wheelbarrow* will not only be the work of a genius, but it will also be the most commercial film of our age, since there is one quality that always rivets everybody's attention – the prodigious!

August

the 1st

I seated ugliness on my knees, and almost immediately I grew tired of it.

the 2nd

We are all hungry and thirsty for concrete images. Abstract art will have been good for one thing: to restore its exact virginity to figurative art.

the 3rd

I dream of a method of curing all diseases – in any case the psychological ones.

the 6th

Summer glides and unravels through my locked jaws as if I were suffering from tetanus. It is already the 6th of August. As I am afraid to start something new, so perfect is the painting on my *Corpus Hypercubicus*, I have a typical Dalí idea. My fear is a lack of testicles. On the other hand, what I have too much of are clenched teeth. As a result, I have gone to work this afternoon on two things that are very distinct and yet coherent: one is the testicles on the torso of Phidias[3]. Result: I have almost stopped being afraid! Bravo, bravo, Dalí!

the 7th

Arrival of the *Gaviota*, Arturo Lopez' yacht, with Alexis and his friends on board. I got up late and took a long dip in the sea which was shimmering like a forest of olive trees. Closing my eyes I seemed to be swimming in liquid olive trees. The night before, knowing the boat was coming, I had dreamed of a sea covered with patches of water colour of all kinds. With the help of a radar I have invented, I organised them into a very beautiful painting 'by radar'. I have profoundly enjoyed every moment of this day, whose theme is as follows: I am the same being as that adolescent who was once so ashamed he did not dare cross the street or the terrace of his parents' house. I blushed so much when I noticed ladies or gentlemen whom I considered to be supremely elegant, that I was often overcome with dizziness and felt I would faint. Today we were photographed in super-disguise. Arturo had on a Persian costume and a

3. The same year as his *Corpus Hypercubicus,* Dalí painted a male torso inspired by Phidias.

necklace of large diamonds with the emblem of his yacht. I, the ultra-revisionist, wore turquoise Turkish trousers and carried an archbishop's mitre. I was presented with the Turkish trousers and with an easy chair that is a copy of a Louis XIV sledge, the back made out of tortoise-shell surmounted by a gold crescent. All this because of the oriental air that imbues the living thousand and one nights with the Galanian biology of our house and its Catalan flowers, our two beds, the Olot[4] furniture, and an extremely rare samovar. The Catalan expedition to the Orient triumphs in our house, where the whitest of kings, who is called Arturo Lopez, comes to rig us up. We lunched in the middle of the harbour (its centre precisely determined by radar) among the most august champagnes and a collection of diamonds and enamelled gold. The Baron de Rédé's beautiful ring was designed by Arturo. I remember having already seen it in one of my megalomaniacal dreams.

For half an hour after Arturo's departure the rocks of Cadaqués were bathed in the style of Vermeer. I think, after all, that the Catalans should return to the Orient. So I have proposed a cruise to Russia in the *Gaviota*. Given the latest political news, eighty girls would gladly see me disembark. I'll play hard to get. They'll insist. Finally I shall appear, and there will be a great burst of applause.[5]

the 8th

I am ruminating yesterday's lunch and prepared for Monday, the day after tomorrow, and for a virginal piece of work as if it were the first time in my life. Never have I enjoyed painting so much. We go to bathe at Junquet, and I enjoy the water more and more. It is proof that my pictorial technique is on the right path, for I can even swim – and for a philosopher swimming is the equivalent of killing one's son. It is for this reason that each time I swim I identify myself with William Tell. How beautiful it would be to see a hundred philosophers swimming and trying to match the rhythm of their breast strokes with the melodies of Rossini's *William Tell*!

Sunday's path of perfection. Everything must be *better*! This summer we shall see the Lopezes twice. My Christ is the most beautiful thing. I feel less tired. My moustache is sublime. Gala and I love each other more and more. Everything must be better! Every quarter of an hour I become even more lucid, and I feel more perfection between my clenched teeth! I shall be Dalí, I shall be Dalí! Now my dreams must be filled with ever smoother and more beautiful images so as to feed my thoughts during the day.

Long live Dalí and Gala!

4. Small town near Figueras where Gala bought a large part of the period furniture for the house at Port Lligat.

5. This news was the death of Stalin.

Am I or am I not destined to create prodigies?

Yes, yes, yes, yes, and yes!

the 10th

I am looking at the tortoise-shell back of the chair Arturo Lopez has given us. The small gold crescent surmounting it can only mean one thing: in a year we shall be able to go to Russia, for otherwise why should this sledge chair with its crescent have come to stay in our room at Port Lligat?

Malenkov has the physique, the consistency, and the quality of an Elephant-brand eraser. We are busy erasing communism. Galatka is getting ready the Cadillac to go to Russia and the *Gaviota* is also being got ready.

And Stalin, the wholly erased, who is he?

And where is his mummy?

the 11th

Just when I was getting ready to work, with the feeling that I must take advantage of every free moment, because I was behind with my painting, Gala told me she would be very unhappy if, just for once, I would not go with her on a trip to Cape Creus. It is the calmest and most beautiful day of the summer and Gala wants me to benefit from it. My first reaction is to say that it is impossible, but, because of this and to make her happy, I accept. When one is busiest, it is a luxury to remain inactive! My desire to be painting will grow keener, and I already feel that because of this unforeseen interruption my painting will be finished in some secret way.

We spend an afternoon worthy of the gods. All those rocks are torsos by Phidias in formation. The most beautiful spot in the Mediterranean lies just between Cape Creus and the Tudela Eagle. The supreme beauty of the Mediterranean is related to the beauty of death. The paranoid rocks of Cullaro and of Francalos are the deadest in the world. Not one of their forms was ever alive or real.

Back from our philosophical outing, we felt exactly as if we had lived through a dead afternoon.

I shall call this historic day: the return from the country of the great soft simulacra, which are hard.

the 12th

In the evening a great many balloons are sent up. One is shaped like a Catalan peasant. It almost catches fire and then is lost in the infinite. When it is hardly bigger than a flea, some say: 'I still see it!' and others: 'It's gone!' Someone is always thinking he can still see it! That reminds me of Hegel's dialectic which is so sad because in it everything is lost in infinite space. Finite space is what we

need, more every day.

We see a falling star of a Veronese green, the biggest I have ever seen, and I compare it with Gala, who has been for me the most visible falling star, the most clearly outlined and the most finite!

the 13th

Philips is a young Canadian painter, a fanatical Dalínian. An angel sent him to me. I have set up a studio for him in a shed. Already he draws with great probity whatever I need, which allows me to dwell at length on the details I like best, with less feeling of guilt. Since six o'clock this morning, Philips has been under the house, drawing Gala's boat as I have asked him to do.

Port Lligat is yellow and arid. It is when I feel rising from the depths of my being my atavistic and Arab thirsts, that I love Gala most.

the 14th

It is because of the fear of touching Gala's face that I will finally be able to paint! Painting should be done spontaneously, all in a rush, letting the contradictory tints melt into lozenges with definite outlines, and applying colour to the light shades to force them into becoming vehicles.

I must take the whole of Gala's face courageously.

the 15th

I savour the afternoon of this day of the Virgin. There is thunder and it is raining. I begin the overpainting of the left thigh, which I then have to leave off for lack of light. I have thought of the need to find dogmas full of certitudes about eternal life. I have the intuition that it will be in the work of Raimondo Lulio that I shall one day find the thing which will convince me. In the meantime my technique is so advanced that I cannot permit myself, even in my thoughts, the joke of dying. Even at a very advanced age.

White hairs, retreat! White hairs, retreat!

Having invented the famous Dalínian fried eggs without frying pan, the result is that I am now 'the anti-Faust without frying pan'.

the 16th

This Sunday I discover the hazel underwater colour of Gala's eyes, a colour which together with that of the marine olive trees moves me all day. All the time I feel like watching those eyes which, after Gradiva, Galarina, Leda, Gala Placida, are, eminently, those of the head (a square metre in size) that will be in my next painting, called *Septembrenel*. It will be the gayest painting in the world. So much so that I intend to succeed completely, surely, in painting

pictures that by their ironical virtues will certainly provoke a noisy and physical burst of laughter.

Philips paints my picture meticulously. To finish it I shall only need to undo everything he has done.

I feel within myself a heroic power that I want to develop to such strength that I shall end up not being afraid of anything!

the 17th

Through excessive caution, I put so little paint on the right thigh that, seeking to add some colour, I smudge my painting. From outside I hear, rising like heavenly music, a murmur of admiration from the people who surround the house. The most re-secret secret is that I, the most famous painter in the world, don't know how a painting is done. Nevertheless I am very close to knowing it, and all of a sudden I shall paint a picture that will surpass those of antiquity. I work on Phidias' testicles to give me courage...

Oh, if only I were not afraid of painting! But, in the end, I want each brush stroke to achieve the absolute and give the perfect image of the painting's testicles, testicles that are not mine.

The asses want me to follow the advice I proclaim for others. This is impossible because *I* am completely different.

the 18th

As soon as I go out, scandal follows at my heels. –Don Juan
TIRSO DE MOLINA

As with Don Juan, scandal breaks out wherever I go. Even during my last Italian campaign, when I landed in Milan, some quite gratuitous people started a lawsuit about the words 'nuclear mysticism', which they claimed to have invented.

An Italian princess has come to see me with a large retinue on board a big yacht. Increasingly they call me *maître*, but what makes me a genius is that my mastery is uniquely a mental thing.

Silence! I believe that tomorrow night the testicles of my Phidias will have inspired me to paint to perfection, notably where the left arm is concerned.

the 19th

With the help of Phidias' testicles I am painting the left thigh in a sublime fashion. I am skirting perfection, which means that I am immensely far away from it, like everything that skirts. But I am skirting, when before I did not skirt.

Some young researchers specialising in nuclear physics came to see me today. They left again, intoxicated, having promised to send me the cubic

crystallisation of salt photographed in space. I should like salt – symbol of incombustibility – to work like me and like Juan de Herrera[6] on the question of the *Corpus Hypercubicus*.

the 20th

I am telling myself once again – but if I did not tell myself again, I don't see who would take it upon himself to do so – I am telling myself that ever since my adolescence I have been vicious enough to believe that I could permit myself anything solely because of the fact that I was called Salvador Dalí. Ever since then I have gone on behaving in the same way, and I have carried it off.

Looking at my painting, I note a fault in the left thigh. This fault results from my unlimited belief in the fusing properties of the underpaint. To be more exact, all I have to do is to squeeze and spread the underpaint till the edges have fused perfectly.

the 21st

Very important: colour may melt on the edges to the point where it disappears. It is necessary to start from the middle and to blend in the edges. The smudges are made by colour that has not blended and not been worked.

the 22nd

Today's secret is to know one should not gallop before summer, which escapes my small clenched teeth. It is all very well for me to clamp them together until almost no freedom is left to time, but I still give it the illusion that it might escape me. All day time is playing that game of which obscure Heraclitus clearly had a vision when he proclaimed: 'Time is a child.' All is verified today by the statement that time is unthinkable without space.

We are eating muscat grapes. I have always thought that a grape held very close to the ear should make some kind of music. So at the end of a meal I have the habit of taking a grape from the bunch and putting it in my left ear. The coolness delights me, and I am already thinking of how to utilise the mystery of that delight.

the 23rd

We are going to Barcelona, where Serge Lifar, M. Bon, and the Baron de Rothschild will bring the models for my ballet. I hope that the music will be really bad. The story that Rothschild has thought up is nothing. So I can

6. Spanish architect of the Escurial, author of *Discourse On Cubical Form* which inspired Dalí's *Corpus Hypercubicus.*

perform Dalínian prodigies quite alone, being assured of the unconditional support of Bon and Lifar.[7]

On the way there I savour my popularity, which continues to grow.

the 24th

It is like a honeymoon with Gala. Our relations are more idyllic than ever. I feel the approach of that courage I have not yet attained in order to make my heroic life a masterpiece altogether. I shall attain it after never having stopped being a hero for one moment.

I have seen Lifar at Barcelona. I invent there and then my scenery with hot-air pumps. When the pumps swell up, they squirt out a table with candelabra. On the table I will put my real loaf of French bread eight yards long.

the 25th

Back at Port Lligat. While I am preparing my palette with the keenest pleasure, I suffer from stomach and abdomen cramp which persists and will not let me sleep. I feel that this incident is providential. The delay inflicted upon me will persuade me all the more forcibly to finish off my *Corpus Hypercubicus*.

the 26th

A day of rain. My cramps disappear. I sleep all the afternoon and prepare to work tomorrow. All these delays are definitely excellent. The house is full of tuberoses and admirable colours. At the moment I am in bed. *El gatito bonito*[8] is purring, making a noise exactly like that produced by my stomach during its intestinal upsets. These two liquid and synchronised sounds give me the greatest satisfaction. Feeling the saliva stuck to the corner of my mouth, I am going to fall asleep.

The north wind blows and predicts that tomorrow I will enjoy a paradisiacal morning light in order to get back to my supra-painting of *Corpus Hypercubicus*.

the 27th

Bravo!

This sickness has been a gift of the Good Lord! I was not ready. I was not worthy to undertake the abdomen and the chest of my *Corpus Hypercubicus*. I practise on the right thigh. My stomach has to recover, my

7. Dalí refers to *Sacre De L'Automne*, to music by Henri Sauguet.

8. "The pretty little cat."

tongue must be very, very clean. Tomorrow I shall work on the testicles of the torso of Phidias, waiting for purification. And then I must learn to blend in the underpaint perfectly from the centre towards the sides.

the 28th

Thank you, my God, for sending that intestinal trouble upon me. It was just what my equilibrium lacked. September is going to begin Septembering. People are gaining weight, whereas in July they commit suicide and go mad, according to statistics. I have ordered a set of scales to be sent from Barcelona. I am going to start weighing myself.

Gala and Juan dress up *el gatito bonito* in a tiger hat with a yellow feather, and we are training it to sleep in a geodesic cradle we brought back from Barcelona. The dusk and the rising of the moon are in tune with the symphonic mewings of the cat and my stomach. This visceral and lunar harmony shows me how to make my *Corpus Hypercubicus* eternally incorruptible. It will be cast in the incorruptible mould of my stomach and my brain.

the 29th

Terror! My fever is rising and obliges me to go to bed in the afternoon. My stomach does not rumble any more, and the cat does not purr any more. I 'see' this small fever as if it were opalescent, iridescent. Will it be the rainbow of my sickness? The doves,[9] which have been silent these last few days, are cooing and taking over from my sick and noisy stomach, in exactly the same way as the lamb took Isaac's place for the sacrifice.[10]

I gave a jasmine to Andrès Sagara, who came to see me with Jones and Foix. We attended a very long banquet in honour of the poet and humanist, Carlos Ribas. They played *sardañas*. Carlos Ribas has spent his entire life studying Greece without being able to understand what that country stood for in antiquity. Like all the humanists of our time, for that matter.

the 30th

I pray to God: my sickness is over. I feel purified. The day after tomorrow I shall be able to start again on painting my *Corpus Hypercubicus*.

I have a Dalínian thought: the one thing the world will never have enough of is the outrageous. That was the great lesson taught by ancient Greece, a lesson that I believe was first revealed to us by Friedrich Nietzsche. Because if

9. In a dovecote bristling with forked wooden crutches, Dalí keeps some twenty birds.

10. Dalí wrote in the margin of his diary that the same gastric trouble plagued him on the same date nine years later. Nine is, we should remember, the cubic figure *par excellence.*

it is true that the Apollonian spirit in Greece reached the highest universal level, it is even more true that the Dionysian spirit surpassed all excess and all outrage. You only have to look at their tragic mythology. Thus I love Gaudí, Raimondo Lulio, and Juan de Herrera because they are the most utterly outrageous people I know.

the 31st

Today, for the first time in his life, Salvador Dalí has felt that angelic euphoria – he has gained weight.

In the morning I was awakened by the beating wings of a pigeon which had got into our room down the chimney. This phenomenon is not just a coincidence. It is the sign that the rumblings of my stomach have really been exteriorised[11]. The cooings of the birds confirm my intuition: I am beginning to listen to myself from outside instead of continuing to listen to myself from within.

The moment has come when Gala and I are going to build ourselves an 'outside'. Among the angels, everything is 'on the outside'. One cannot conceive of them except by their 'outsides'.

The dermo-skeleton of Dalí's soul begins today.

Daisy Fellowes, accompanied by a gentleman in beautiful red trousers bought at Arcachon, came to dinner.

11. Nine years later, Dalí was to jot down in a completely different handwriting, in the margin of his diary: 'Synchronically, I have decided in this year '62 to construct walls containing cybernetic machines, because my brain can no longer be kept in my head nor in my house. I shall build them outside my house. Instead of the intestinal cooling of the years up to '53, it is my brain – whose circumvolutions have assumed intestinal characteristics – that will function.'

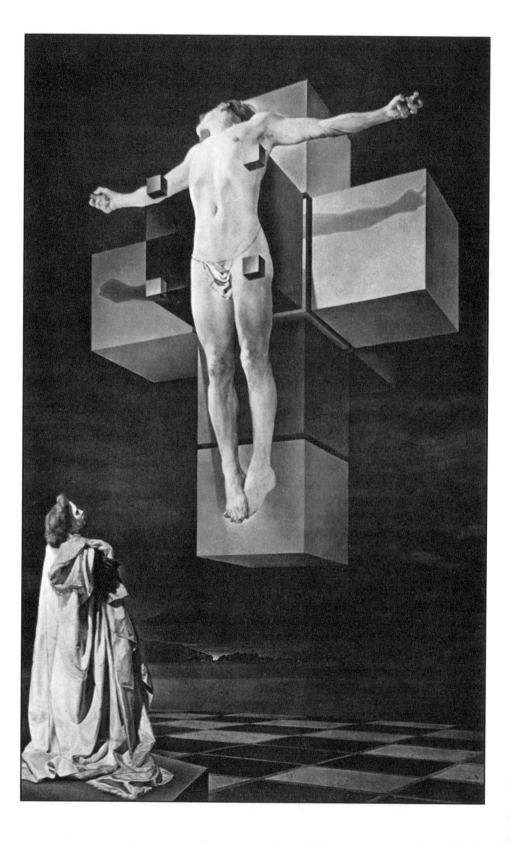

September

the 1st

September will September Gala's smiles and corpuscles. *Corpus Hypercubicus* will October. But – and above all – the month of September must hyper-Galatate.

I am painting the upper part of Christ's chest. I hardly eat during this work. I ingurgitate only a little rice. Next summer I'll have a hyper-white suit made to paint in. I become increasingly clean. I will end up allowing myself only the sublime and hardly perceptible smell of my feet mixed with that of the jasmine behind my ear.

the 2nd

I am improving. I find new technical resources.

This afternoon I did not want to see an unknown gentleman, but coming out of the house to enjoy the dusk over Port Lligat, I find the gentleman still waiting, hoping to see me all the same. I talk to him and learn that he is by profession a whaleman. Immediately, the same instant, I request him to send me several vertebrae of this mammal. He has promised to do so with the utmost diligence.

My capacity to profit from everything is unlimited. In less than an hour I have listed sixty-two different applications for these whale vertebrae – a ballet, a film, a painting, a philosophy, a therapeutic decoration, a magical effect, a hallucinatory method both Lilliputian and psychological because of its so-called phantasies of grandeur, a morphological law, proportions exceeding human measurement, a new way to pee, a brush. All this in the shape of a whale's vertebrae. After this I try to recall the olfactory memory of a rotting whale that I went to see at Puerto de Llansa[12] when I was a child, and just as I rediscover that smell, I see behind my closed eyes, in a completely hypnagogic state, a shape that gradually comes to represent a sort of Abraham sacrificing his son. This shape is of a whale-grey colour, as if it had been cut out of the cetacean's very flesh.

I fall asleep to a tune from *La Belle Hélène*. *La Belle Hélène* and the whale (*baleine*) intermingle phonetically in my subconscious mind.

12. A small port north of Cadaqués, on the Costa Brava.

the 3rd

The Count de G., a typical Dalínian protagonist, said: 'One gives balls for those that are not invited'. Even though I have received several wires begging me to come to the Marquis de Cuevas' ball, I stay at Port Lligat, but the newspapers, always alert and precise, still comment on my presence in Biarritz. The most successful balls are those which are talked about most by those who were not there. The fried egg without frying pan of the ball without Dalí, is Dalí.

In the evening Gala is overcome with admiration before my paintings. I go to bed happy. Happy scenes of our real chimerical life. Dear September, the beautiful paintings embellish us. Thank you, Gala! It is through you that I am a painter. Without you, I would not have believed in my gifts! Give me your hand! It is true that I love you more and more.

the 4th

While I was talking to a fisherman who mentions his age, I suddenly decide I am fifty-four years old.[13] I am in a torment during my entire siesta, whereupon I tell myself that I may be counting backwards! I even remember that, after the publication of my *Secret Life*, my father told me that I had given myself an extra year. So it is possible that I am actually no more than forty-eight years old! These years gained – fifty-three, fifty-two, fifty-one, fifty, forty-nine – are a great comfort to me, and at once I paint, even better than I expected, the breast of my *Corpus Hypercubicus*. Now I am going to apply a new technique: I am going to be happy with all I do and make Gala happy, so that everything will be better for us. We are going to work harder than ever!

All problems, and you, white hairs, retreat!

I am the mad tool – without the frying pan and without the egg!

the 5th

In the coming year I shall be the finest and the *fastest* painter in the world.

At one time I thought one could paint with very liquid, semi-opaque paint, but it is no use. The liquid paint is absorbed by the amber, and everything turns yellow.

the 6th

Each morning, on awakening, I experience a supreme joy which, for the first time today, I discover is the joy of being Salvador Dalí, and I wonder, full of amazement, what sort of prodigies this Salvador Dalí will produce today. And

13. Dalí, born in 1904, was actually forty-nine at the time.

each day I find it more difficult to understand how other people can live without being Gala or Salvador Dalí.

the 7th

Hyperspherical Sunday. Gala and I went with Arturo, Joan, and Philips as far as Portolo. We disembark on the island of Blanca.[14] It is the most beautiful day of the year.

Galatea, the Gala nymph of pure and gigantic marine geology, is slowly but ineluctably taking shape in the Raphaelite-nuclear impulse of my next and brilliant painting.

In the evening a photographer from Paris comes to see me. He tells me that Joan Miró has disappointed everybody. He makes too many strokes on his canvas, as though he were ironing on his colours. The abstract painters number thousands. Picasso has aged greatly in a few months.

The weather gets more beautiful all the time. Before we go to sleep, Galatea eats a big hyper-almond of herring! This Sunday also had to end with an enormous marine geological sugar egg, purely Raphaelesque, Galatean, and Dalínian, while in Paris the sur-existentialist artistic shit is in full decline.

the 8th

I am finally painting Gala's face in a most satisfying way.

the 9th

I have been working on the yellow drapery with great decision.

In the evening, Margarita Alberto, Dionisio and his wife came to dinner. Gala wore a coral necklace. Margarita told us all about the Marquis de Cuevas' ball and the incident between the Prince of Irlonda and the King of Yugoslavia. After that we talked about death. Gala alone is not afraid of it. She is concerned only to know how I would live if she were no longer with me. Embarrassed, Dionisio recited a passage from Caldéron's *Life Is A Dream*. He has a vague idea, perhaps even a hope, that he is its author, so much so that he takes himself for a throw-back to José Antonio.

As we went to bed very late, I did not fall asleep, which gives me the courage to paint once again, the next day, the arm of my *Corpus Hypercubicus*. The visit of my friends has been like the soft shadows of autumn. More and more, everything becomes invisible around Gala and Salvador Dalí. We shall soon be the only real and transcendent beings of our age. Dionisio has done a portrait in oil of me disguised as a Chinaman.

14. A small island off the Cape of Creus.

The Cuevas ball has passed by like a shadow of disguised phantoms. Gala and Dalí alone are disguised by an already indestructible mythology. I love us both so much...

It is forbidden ever to do a representation of a clown.[15]

the 10th

Remember this ... Dampen with amber, pressing very hard – amber that has been thoroughly dissolved in turpentine. Today your mistake was to put in too much amber. With the liquid, impregnate a small brush, very long and very fine. You will cover your painting without stains, because stains are caused by an excess of matter which it is difficult to blot up at the corners, while you can control the liquid just as you like. To paint the crucial passages, more liquid colours are required, for the supreme touches, very liquid...

The weather has changed. It has been raining and the wind is high. The maid prepares a *galateau* [pun on the word for cake, *gâteau*, and Gala] while I watch. I am on the verge of knowing everything necessary to paint prodigiously. Soon, all will exclaim: 'What Dalí paints is marvellous!' I shall owe this to the patience and equilibrium that Gala bestows on me, as well as to my *Corpus Hypercubicus* and to the testicles of Phidias in which I see supreme values.

the 11th

I am working once more on the left thigh. Again, while drying, it smudges. The stain will have to be treated with potato and then I shall simply have to repaint hypercubically without rubbing or scumbling.

the 12th

Worked again on the yellow drapery which is getting better all the time. Today something unique! For the first time in my life I have the real, vital urge to visit an art gallery.

the 13th

If I had painted well all my life, I could never have been happy. Now it seems to me that I am at the same state of maturity as Goethe was when he arrived in Rome and exclaimed: 'At last I am going to be born!'

15. *Laugh, Clown, Laugh* is the title of an essay that has been in preparation for years now. Dalí intends to show in it that the mechanism which best releases laughter and emotion in an audience is that of the clown who receives a moral or physical blow on the head. See the end of *The Blue Angel*.

the 14th

Eighty girls ask me to show myself at the window of my studio. They applaud me, and I send them a kiss. I feel the most exquisite of Chaplins, if he had been exquisite. I withdraw from the window, my head full of reflections that are not new: 'What can one do in order to know at last how to paint very well!'

the 15th

Eugenio d'Ors, who has not been back in Cadaqués for fifty years, comes to see me, surrounded by friends. He is drawn by the myth of Lydia of Cadaqués.[16] It is of course possible that both our books on the subject will appear simultaneously. In any case, his book, which is vaguely aesthetic and pseudo-Platonic, can only make the realistic edges and hypercubicus of my 'well-planted' Lydia shine the more.

the 16th

They wake me up late. It is raining hard, and it is so dark that I will not be able to paint. I realise the technical failure of this month of September. While I was painting the draperies better than ever, I also tried, because of a chimerical desire for absolute perfection, to paint with almost no paint on surfaces saturated with amber. I wanted to attain the utmost mastery, the maximum of the quintessence of dematerialisation. The result was disastrous. For an hour, the area I had painted was superb; but on drying, the amber absorbed the coloured part and everything turned the colour of dark amber and was covered with stains. This darkening of my *Corpus Hypercubicus* has found its synchronisation in the leaden rain clouds of this 16th of September. They have darkened my life for an afternoon. But towards evening I became conscious of the most original origin of my mistakes. I savour these mistakes. Gala knows everything can be very easily corrected by rubbing with a potato before repainting. My pleasure is to uncover all the truths of my painting technique with the help of my episodic and momentary failure. For a few moments more, I savour my sin absolutely, and then I ask them to bring me something that is at once very relative and very real – a potato, to call it by its name. And as it is put on my table, I heave a sigh like Goethe. At last I am going to be born!

It is good to begin being born on a horrible stormy day!

16. In his *Secret Life*, Dalí told the story of this Catalan matron who received him with Gala when he was driven out of his father's house. Lydia, the 'well-planted', cultivated an imaginary love for Eugenio d'Ors whom she had glimpsed once in her youth.

the 17th

I am painting the draperies and the shadow of the arms. In Mexico a man has just died at the age of a hundred and fifty, leaving an orphan of a hundred and one. How I would love to live even longer than that! I am always expecting a substantial prolongation of life from the special sciences (and with the help of God, of course). In the meantime, to 'begin being born', as happened to me yesterday, is already a way of enduring. Persistence of memory, soft watch of my life, do you recognise me?[17]

Gala has gone to Barcelona with Joan. We are going to fish in the twilight sky of the bats, armed with long rods at the end of which we have attached black silk socks, the socks worn on formal evenings in New York.

Good evening, Gala, I am going to touch wood so that nothing bad will happen to you. You are me, you are the pupils of my eyes and of your eyes.

the 18th

An electrician came up to see my *Corpus Hypercubicus*. After a stunned silence, he exclaimed: 'Cristu!' In Catalan, that is the equivalent of a superlative, categorical and weighty swear-word.

the 19th

I am painting a large area of drapery with more assurance than ever, and I draw the cloth destined to cover the sex of my *Corpus Hypercubicus*. All this in spite of vicious failures in the electric current.

the 20th

I am doing the overpainting of the cube with its left shadow. In the evening, I paint what I drew the day before – that is to say, the cloth that covers the sex of my *Corpus Hypercubicus*. I am in bed. Gala has gone off shrimp fishing with some friends.

the 21st

I open an old copy (dated 1880) of *Nature* and read a story that is 100 per cent Dalínian. A sword swallower was indisposed by a fork that had fallen into his stomach during a party with some friends. A certain Dr. Polaillon removed it

17. Allusion to the very famous painting by Dalí, of which the painter has given the following definition: 'After twenty years of complete immobility, the soft watches disintegrate dynamically while the chromosomes continue the hereditary duty of the genes of my prenatal Arab atavisms.'

after a spectacular operation. The story would have been 200 per cent Dalínian if the fork had been a turd. I am revising it along these lines, as concretely as possible, respecting all its exasperating details:

'A very interesting communication was made to the Academy of Medicine by Dr. Polaillon, at the session of the 24th of August last. We herewith furnish some excerpts:

'I have the honour to present to the Academy a turd that I removed yesterday by an incision in the stomach.The patient is named Albert C———, twenty-five years old, exercising the profession of magician and juggler, and specialising in scatological turns with an Arab lady friend. While at Luchon, on the 8th of this month, he amused himself with friends by swallowing dry turds of all kinds. One of these lodged in his oesophagus and, on the point of suffocating, Albert C——— inhaled deeply and fainted. Having regained his breath he tried several times to grasp the turd by plunging his fingers deep into his pharynx. But without success. The turd descended slowly through the oesophagus and penetrated into the stomach. The only result was some bloody phlegm resulting from excoriations of the pharyngeal and oesophageal linings, and the next day he continued his scatological exercises. A few days later, he felt a discomfit in the epigastric cavity and consulted several doctors. Dr. Lavergne suggested that he come to Paris and was kind enough to recommend my services. He became my patient at the Pitié Hospital on the 14th of August, six days after his accident.

'Albert C——— is of more than average height. His muscles are well developed, though his arms and legs are rather skinny. His stomach is flat, without any layers of fat, and one can see under the skin the bulges and indentations of his abdominal muscles; his sex is extremely small but vile with gratification. He explained very clearly that the turd had penetrated his stomach by its rounded extremity, and that he felt it in the upper part of his stomach. According to him, it was in an oblique position, following a line that was supposed to run a bit higher than the umbilicus and proceeding from the lower left to the upper right; its sharp extremity being concealed in the left hypochondrium and its rounded extremity embedded slightly below and outside the umbilicus in the right hypochondrium.

'The turd was exceptionally hard and of a large size. The patient had noticed that he suffered pain when his stomach was empty. As a result he was obliged to eat very often in order to diminish his pains. By the way, the functioning of stomach and intestines was normal. There had been neither spitting of blood nor vomiting.

'The introduction of the oesophageal probe with a metal awl afforded no results whatsoever. This probe, devised by Mr. Collin, is meant to transmit to the investigator's ear a very distinct sound as soon as its awl comes into contact with a foreign body situated in the stomach. Since this instrument had not enabled us to hear anything, we began to feel some doubts about the

existence of a turd in the stomach. These doubts seemed to be confirmed by the suffering and anguish caused to the patient by the introduction of the oesophageal probe. It seemed unlikely that a man used to swallowing turds should experience so much pain from the passage of a small oesophageal probe.

'In order to dispel my doubts, I enlisted the help of M. Trouvé, who, with his customary obligingness, had an oesophageal probe constructed on the principle of his scalpel, with an electric signal to reveal the presence of the excremental object in the tissues. At the moment the extremity of this probe penetrated into the stomach, one of my assistants, M. Trouvé, and I heard the revealing sound of the electric battery for a fraction of a second. But the sound, which we failed to produce again, had been so brief that I was not wholly convinced.

'The following explorations devised by M. Trouvé enlightened the diagnosis completely:

'1. A magnetic needle of extreme delicacy pointed to the patient's stomach region, when he approached the needle. When the patient made some movements, the magnetic needle followed these.

'2. A large electro-magnet, placed a few millimetres from the abdominal wall, suddenly occasioned a small projection of the skin when the current was turned on, as if an intra-abdominal object was being drawn towards the electro-magnet.

'When the electro-magnet was suspended from a string, in such a way as to be facing the patient's stomach, the electro-magnet could be seen to swing out and apply itself to the skin each time the current was turned on.

'These curious experiments clearly indicated that a foreign body consisting of excrement existed in the upper part of the abdominal cavity.

'Putting our positive experimental findings together with the sensations of the patient, with our explorations by external examinations of the stomach, and with the introduction of the electric oesophageal probe, we became certain of the presence of a dry turd in the stomach.

'Once the diagnosis had been made, there remained the task of extracting this foreign body. Since surgeons have never succeeded in extracting a foreign body as voluminous as this by means of tongs or other instruments introduced through the oesophagus, I did not bother to make any attempts in that direction, and I decided to proceed with an incision of the stomach.

'The operation of the stomach incision, carried out according to the principles recommended by Dr. Labbé, was executed on the 23rd of August, and the turd was removed from the stomach: moreover Dr. Polaillon has introduced some simplifications in the method of operating.

'Following this communication, Baron Larrey has brought to our attention the fact that the stomach incision was performed in very ancient times, and that he remembered having seen in an old book an account of a turd that had been swallowed by a girl. A few months later the swallowed turd worked through towards the epigastrium, and by taking this swelling as his guide the

surgeon incised the abdominal wall and stomach wall, reached the turd, and was able to extract it.'

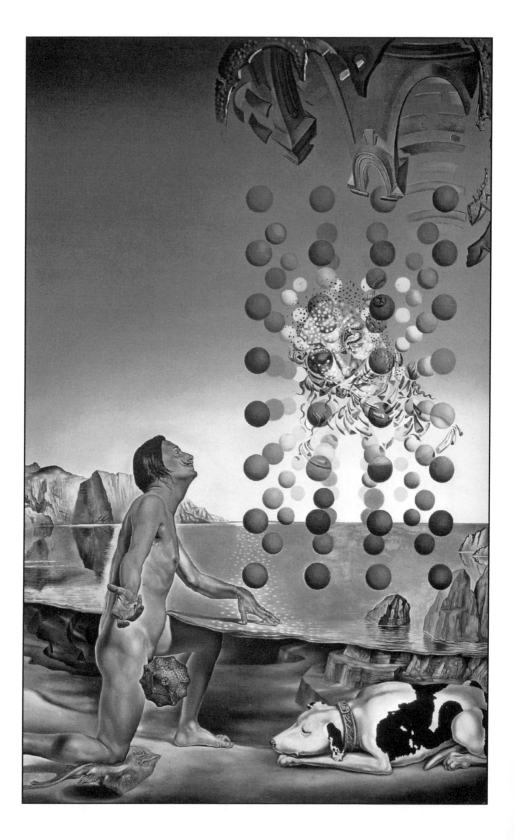

1954

No entries.[1]

1. Despite appearances, the year 1954 is not an empty one. On the contrary, it is one of the fullest in Dalí's life. He began by writing a play in three acts: *Mystic Erotic Delirium* for three actors. This lyrical drama, of a violent verbal eroticism, can be performed only to an élite audience, as might be expected. Dalí also began his film *Prodigious Adventure Of The Lacemaker And The Rhinoceros*, produced designs (unused) for the film *Seven Wonders Of The World*, and completed several paintings.

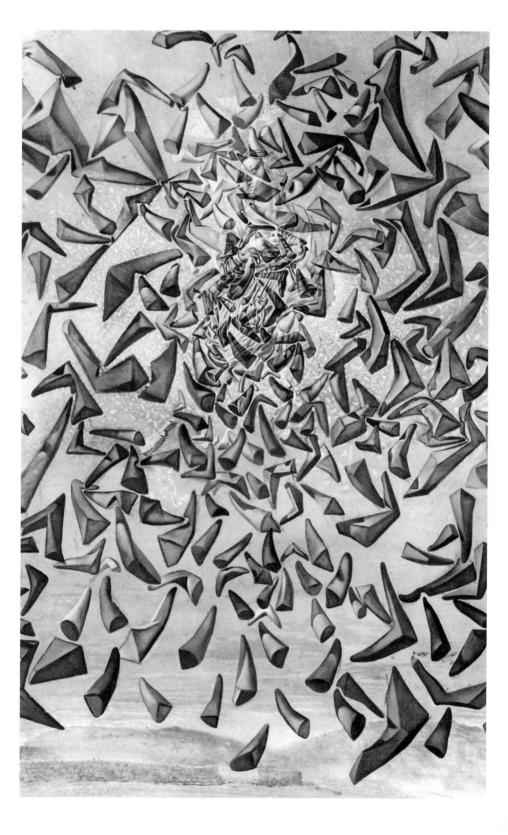

1955

December

Paris, the 18th

Dalínian apotheosis last night in the Temple of Knowledge before a fascinated crowd. I had barely arrived in my Rolls stuffed full of cauliflowers, when I was greeted by thousands of exploding flash-bulbs. I took the floor in the great amphitheatre of the Sorbonne. The tremulous audience were expecting some decisive words. They got them. I had decided to communicate in Paris the most intoxicating intelligence of my life, because France is the most intelligent country in the world, the most rational country in the world. Whereas I, Salvador Dalí, come from Spain, which is the most irrational and the most mystical country in the world... Frantic applause received these first words, for no one is more sensitive to compliments than a Frenchman. Intelligence, I said, merely leads us into the fog of scepticism's nuances, and its principal effect is to reduce things for us to the coefficients of a gastronomic and super-gelatinous, Proustian and spoiled incertitude. For these reasons it is good and necessary that from time to time Spaniards like Picasso and me should come to Paris to set before the eyes of the French a raw and bloody hunk of truth.

At this, there were various stirrings, as I had expected. I had won!

Then I said, all in one breath: 'One of the last most important modern painters was certainly Henri Matisse, but Matisse precisely represents the last consequences of the French Revolution, namely the triumph of the bourgeoisie and of bourgeois taste.' Thunderous applause!

I went on: 'The consequences of contemporary modern art have brought us to the maximum of rationalisation and the maximum of scepticism. Today, young modern painters believe in *nothing*. It is entirely natural that when one does not believe in anything one ends by painting nothing, which is the case in all modern painting, including abstract, aesthetic, academic painting, with the single exception of a group of American painters in New York who, through lack of tradition and because of an instinctive paroxysm, are very close

to a new pre-mystic faith that will take form when the world is finally conscious of the latest progress of nuclear science. In France, at the pole diametrically opposed to that of the New York school, I can find only one example to give you, and that is my friend, the painter Georges Mathieu who, because of his monarchic and cosmogonic atavisms, has adopted an attitude that is completely contrary to the academicism of modern painting.'

At this point, profound bravos again underscored my revelations. I could do nothing more but communicate to them the pseudo-scientific intelligence I had been meditating. I know I am not an orator, or even a man of science, but the audience must have included scientists and especially morphologists who would judge the creative and valid character of my delirium.

At the age of nine, I told them, I was at Figueras, my birth-place, sitting more or less naked in the dining-room. I was leaning my elbow on the table, and I had to pretend to be asleep so that a young servant girl could look at me. On the table were crumbs of dry bread which were pressing painfully into the flesh of my elbow.[1] The pain corresponded to a sort of lyrical ecstasy which was preceded by the song of a nightingale. That song moved me to tears. Immediately afterwards, I was obsessed in a truly delirious fashion by Vermeer's Painting of the *Lacemaker*, a reproduction of which was hanging on the wall of my father's study. Through the door, which had been left ajar, I could see that reproduction and at the same time I was thinking of rhinoceros horns. Later my friends judged my illusion to have been delirious, but it was true, and when I was a young man I happened to lose a reproduction of the *Lacemaker* in Paris. I was sick about this, and I couldn't eat until I had found another one...

The whole audience listened to me breathlessly. I had only to continue and to explain how my constant preoccupation with Vermeer and especially with his *Lacemaker* led to a crucial decision. I asked permission from the Louvre to do a copy of this painting. And one morning I arrived at the Louvre, thinking about rhinoceros horns. To the great surprise of my friends and of the chief curator, rhinoceros horns appeared in the drawing on my canvas.

The tension of my audience was transformed into an enormous burst of laughter, immediately drowned in applause. Frankly, I concluded, I rather expected this would happen.

Then a reproduction of the *Lacemaker* was projected on a screen, and I was able to show what affects me most in that painting: everything converges exactly towards a needle which is not drawn but merely suggested. And the sharpness of that needle I have felt very acutely in my own flesh, in my elbows when, for instance, I wake up with a shock in the middle of my most paradisiacal siestas. Up till now, the *Lacemaker* has always been considered a very peaceful, very calm painting, but for me, it is possessed by the most violent

1. Dalí has often said that all his important emotions enter by way of his elbow. Never through his heart!

aesthetic power, to which only the recently discovered antiproton can be compared.

I then asked the operator to project on the screen a reproduction of my copy. Everybody stood up, applauding and calling out: 'It's better! It's obvious!' I explained that until I made that copy I had understood nothing of the *Lacemaker*, and that I had needed a whole summer to work out the question, to realise that I had drawn by instinct the most rigorous and logarithmic curves. The collision of the bread crumbs, and of corpuscles, again makes the image of the *Lacemaker* visible. Later I decided I should go on with the painting: my rhinocerontic ideas were so obvious that I sent a telegram to my friend Mathieu telling him: 'This time no Louvre. I must face a living rhinoceros.'

To relax the atmosphere and to bring my public back to earth, since they were beginning to get dizzy, I had a photograph shown of Gala and me bathing in the water at Cape Creus flanked by one of the portraits of the *Lacemaker*. The fifty other portraits were scattered over my olive grove, constantly inviting me to new reflections on this problem whose significance is infinite, while at the same time I went deeper into my studies of the morphology of the sunflower, about which Leonardo da Vinci had already drawn some very interesting conclusions for his period. That summer of 1955, I discovered that in the junctions of the spirals that form the sunflower there is obviously the perfect curve of the rhinoceros horn. At present the morphologists are not at all certain that the spirals of the sunflower are truly logarithmic spirals. They are close to being so, but there are growth phenomena which have made it impossible to measure them with rigorously scientific precision, and the morphologists do not agree on whether or not they are logarithmic spirals. However I was able to assure the audience at the Sorbonne yesterday that there never has been a more perfect example in nature of logarithmic spirals than those of the curve of the rhinoceros horn. Continuing my study of the sunflower and still selecting and following the more or less logarithmic curves, it was easy for me to distinguish the very visible outline of the *Lacemaker* – her hair-do and her pillow, rather in the style of a divisionist painting by Seurat. In each sunflower I found perhaps fifteen different *Lacemakers*, some closer to the original Vermeer painting than others.

'That is why,' I continued, 'the first time I saw a photograph of the *Lacemaker* and a live rhinoceros together, I realised that if there should be a battle, the *Lacemaker* would win, because the *Lacemaker* is morphologically a rhinoceros horn.'

Laughter and applause greeted the first part of my lecture. All that remained for me to do was to show my audience the poor rhinoceros carrying at the end of his nose a tiny *Lacemaker*, whereas the *Lacemaker* herself was a huge rhinoceros horn possessing the greatest spiritual strength because, far from having the bestiality of the rhinoceros, she was the symbol of the absolute monarchy of chastity. A canvas by Vermeer is the exact opposite of a canvas by Henri Matisse, exemplary prototype of weakness because, notwithstanding his

gifts, his painting is not chaste like that of Vermeer, who does not touch the object. Matisse does violence to reality, transforms and reduces it to a Bacchic proximity.

Always careful not to let my audience indulge in reflections other than my own, I had a picture of my *Corpus Hypercubicus* shown, thus exhibiting to one and all a more or less normal painting which my friend Robert Descharnes, who is at the moment shooting a film called *Prodigious Adventure Of The Lacemaker And The Rhinoceros*, has analysed as Gala's face obviously formed by eighteen rhinoceros horns.

This time my peroration was not greeted by scattered bravos but by actual hurrahs, which were renewed when I added that some people have seen an obvious eucharistic connection between the bread and the knees of Christ, from the point of view of matter as well as in the morphology of the forms. All my life I have been obsessed by the bread I have painted an incalculable number of times. If one analyses certain curves in my *Corpus Hypercubicus*, one finds the almost divine curve of the rhinoceros horn, which is the essential basis of all chaste and violent aesthetics. The same horns, I went on to show, pointing at the screen on which my painting of the limp watches was projected, can already be found in that early Dalínian work of art.

'Why are they limp?' a listener asked.

'Limp or hard,' I answered, 'that is not important. The important thing is that they keep the right time. In my painting there are symptoms of rhinoceros horns which stand out and allude to the constant dematerialisation of that element which in me transforms itself more and more into a decidedly mystical element.'

No, certainly the rhinoceros horn is not of a romantic or Dionysian origin. On the contrary, it is Apollonian, as I discovered by studying the shape of the neck in Raphael's portraits. By such analyses, I discovered that everything is composed of cubes and cylinders. Raphael painted solely with cubes and cylinders, forms that are similar to the logarithmic curves observable in rhinoceros horns.

To confirm what I had been saying, a slide of my copy of a Raphael painting was projected, visibly influenced by my obsessions with the rhinoceros. This painting – a Crucifixion – is one of the great examples of the conic organisation of a surface. As I have already stated, it was not the rhinoceros horn as we find it in Vermeer (where it has much greater force) – no, it is the rhinoceros horn that one might call neo-platonic. A diagram has been made of this painting, showing the essential thing in it – a diagram in which all the figures are divided according to the divine monarchic proportion of Lucas Pacelli, who constantly uses in aesthetics the word 'monarchy' because the five regular bodies are entirely governed by the absolute monarchy of the spheres.

Again my audience were holding their breath. I had to provide them with other raw truths. The photograph of a rhinoceros's behind was projected, which I had analysed very subtly not long before, only to discover that it was

nothing but a sunflower folded double. The rhinoceros is not satisfied with bearing one of the most beautiful logarithmic curves on the point of its nose, but in addition it wears on its behind a sort of galaxy of logarithmic curves in the shape of a sunflower.

Yells and bravos burst out. I had the whole audience in the palm of my hand. We were in a state of pure Dalínism. It was the moment to start prophesying.

'After the morphological study of the sunflower,' I said, 'I became aware that its points, its curves and its shadows had a taciturn character precisely in keeping with the profound melancholy of Leonardo da Vinci himself. Then I asked myself whether this was not too mechanical. The dynamic mask of the sunflower prevented me from seeing the *Lacemaker* in the sunflower. I was studying the question when I happened across a photograph of a cauliflower... Revelation – the morphological problem of the cauliflower is identical to that of the sunflower insofar as it, too, is composed of true logarithmic spirals. But the rosettes have a sort of expansive force, almost an atomic force. A budding tension similar to that obstinate and meningitic forehead I love so passionately in the *Lacemaker*. I had come to the Sorbonne in a Rolls full of vegetables, but the season was not right for giant cauliflowers. We would have to wait till next March. The biggest one I find I shall light and photograph from a certain angle. Then – and I give my word of honour as a Spaniard on it – once the photograph has been developed, everybody will see a *Lacemaker* in it and one full of Vermeer's own technique.'

An absolute frenzy seized the hall. Now all I had to tell them were some anecdotes. I chose the one about Genghis Khan. I had been told that one day Genghis Khan had heard a nightingale singing in a paradisiacal spot where he wanted to be buried, and the next day he had seen, in a dream, a white rhinoceros with red eyes, an albino. Considering this dream to be an omen, he renounced the conquest of Tibet. Is this not strikingly similar to my childhood memory which, it will be remembered, also began with the singing of a nightingale preceding the obsession with the *Lacemaker*, the crumbs of bread, and the rhinoceros horns? And just when I was studying the life of Genghis Khan, I received the request to make this lecture from M. Michel Genghis Khan, permanent secretary-general of the International Centre of Aesthetic Studies. To me with my characteristic and congenital imperialism, this was a remarkable and genuine coincidence.

Another anecdote: Two days ago another most upsetting coincidence. I was dining with Jean Cocteau[2] and was telling him about the subject of this talk, when I saw he was turning pale.

'I have something that is going to dazzle you.'

And in front of the fascinated audience who were in a paroxysm of curiosity, I waved the 'object' in the air: the torch with which Vermeer's baker

2. At this point, there were stirrings in the hall.

lit his oven. Vermeer, who had no money to pay his baker, used to give him, in exchange for bread, some paintings and other objects, and the baker would light his oven with this object from Delft, which contains the bird and the horn which is not a rhinoceros horn but which is perhaps more or less logarithmic all the same. It is an extremely rare piece because Vermeer is a very mysterious person. Nothing except this object is known about him.

But the hall had stirred when I mentioned Jean Cocteau, and I was obliged to say that I adore members of the French Academy. This was enough to make everybody applaud. I adore members of the French Academy especially since one of the most illustrious members of the Spanish Academy, the philosopher Eugenio Montes, said something that I liked very much because I have always considered myself to be a genius. He said: 'Dalí is the being closest to the archangelic Raimondo Lulio.'

Thunderous applause greeted this quotation.

With a gesture I silenced the bravos and added: 'After my remarks this evening, I think that in order to be able to proceed from the *Lacemaker* to the sunflower, from the sunflower to the rhinoceros, and from the rhinoceros to the cauliflower, one must really have something inside one's skull.'

1956

May

Port Lligat, the 8th

The papers and the radio announce with great to-do that today is the anniversary of the end of the war in Europe. When I got up this morning, on the stroke of six, I was inspired by the idea that it was probably Dalí who won the last war. This thought delighted me. I did not personally know Adolf, but theoretically I might have met him in private on two occasions before the Nuremberg Congress. On the eve of this congress, my intimate friend Lord Berners asked me to sign my book *La Conquête De l'Irrationnel* in order to give it personally to Hitler, as he saw in my painting a Bolshevik and Wagnerian atmosphere, especially in the way I represented cypress trees. At the moment of signing the copy Lord Berners proffered me, I was overcome by a curious perplexity; and remembering the illiterate peasants who came to my father's office and signed with a cross the documents that were set before them, I contented myself, in my turn, with drawing a cross. I realised as I did it (as with anything I do for that matter) that this must be very important, but never, absolutely never, did I have the slightest idea that this was precisely the sign that was to provoke the ultimate Hitlerian catastrophe. In fact, Dalí, who is a specialist in crosses (the greatest that has ever existed), managed in two gentle strokes to express graphically, magisterially, indeed magically and in a condensed fashion, the fifth essence of the total conflict of the swastika, the dynamic, Nietzschean, hooked Hitlerian cross.

I had drawn a stoic cross, the most stoic, the most Velasquezian and the most anti-swastika of all, the Spanish cross of Dionysian serenity. Adolf Hitler, who must have antennae charged with magic, stuffed with horoscopes, must have been frightened for quite a long time, till his death in the bunker at Berlin, because of my augury. There is no doubt that Germany, in spite of its superhuman efforts to be vanquished, lost the war, and that it was Spain which, without taking part in the conflict, without doing anything, humanly alone,

with her Dantesque faith and the help of God, was led to win, won, is still winning and will spiritually continue to win this same war. The whole difference between Spain and the Germany of a masochistic Hitler is that we Spaniards are not Germans, and that we are even rather the opposite.

the 9th

I disanthropise chance. I penetrate ever deeper into the contradictory mathematics of the universe. These last two years I have finished fourteen canvases, each more sublime than the next. The Virgin and the infant Jesus shine through all my paintings. Here, too, I apply the most rigorous mathematics: that of the archicube. Christ pulverised into 888 splinters which dissolve into a magic nine. Now I am going to stop painting with my prodigious precision and my immense patience. Quick, quick, I am going to give all of myself, all at the same time, powerfully, gluttonously. This became quite obvious when, in Paris one morning, I went to the Louvre to paint Vermeer's *Lacemaker* in less than an hour. I wanted to depict her between four crusts of bread, as if she had been born of a molecular encounter according to the principle of my four-buttocked continuum. Everybody saw a new Vermeer.

We are entering the era of great painting. Something came to a conclusion in 1954 with the death of that painter of seaweed who was just good enough to encourage the middle-class digestion. I mean Henri Matisse, painter of the Revolution of 1789. It is the aristocracy of art that is reborn in the delirium. From Communists to Christians, everybody has taken a stand against my Dante illustrations. They are a hundred years too late! Gustave Doré conceived hell as a coal mine; I saw it under the Mediterranean sky, with an exacerbated horror.

Now the time of my film is approaching, which I have already discussed at length in my diary: *The Flesh Wheelbarrow*. Since I first thought about it, I have brought its scenario to perfection: the woman who is in love with the wheelbarrow will live with it and with a child as beautiful as a god. The wheelbarrow will assume all the attributes of the world.

the 10th

I am in a state of permanent intellectual erection, and all my desires are granted. My liturgical *corrida* is beginning to become a reality. Many people are beginning to wonder if it has not already taken place. Courageous priests volunteer to dance around the bull, but considering the great Iberian and hyper-aesthetic conditions of the bull-ring, the most powerful eccentricity will consist in substituting for the banal and circular removal of the bull by ordinary mules, a removal by vertical elevation, by means of an autogyro, an eminently mystical instrument and one that draws its power from itself, as its name indicates. To render the spectacle even more devastating, the autogyro must carry the carcass

very high and very far, for instance to the mountains of Montserrat, so that the eagles will devour it in order to achieve in a pseudo-liturgical way a *corrida* such as has never been seen before.

I want to add that the only totally Dalínian way of decorating the bull ring (even though it is a slight plagiarism from Leonardo) will be to hide behind the *contrabarrera* two hoses that will assume all sorts of shapes (preferably intestinal ones). At a given moment, these hoses will come to a state of erection in a truculent and apotheositic manner by means of the pressure of a violent spurt of boiling, preferably curdled, milk.

Long live the vertical Spanish mysticism which from the abyssal submarine of Narcisse Monturiol[1] mounts vertically to heaven by means of a helicopter!

the 11th

Every year – it is a regular event – a young man comes to ask me how to succeed. To the one who came this morning, I said:

'In order to acquire a growing and lasting respect in society, it is a good thing, if you possess great talent, to give, early in your youth, a very hard kick to the right shin of the society that you love. After that, be a snob. Like me. With me, snobbery started in my infancy. I already admired the superior social class that in my eyes was incarnated in the person of a lady called Ursula Mattas. She was from Argentina, and I was in love with her, first of all because she wore a hat (hats were not worn in my family) and because she lived on the second floor. After my early youth, my snobbery did not limit itself to the second floor. I have always wanted to be on the most important floors. When I came to Paris, I had an absolute obsession to know if I would be invited to all the places where I believed one had to be seen. Once the invitation has been received, snobbery is immediately assuaged, in the same way that one's illness is cured the moment the doctor opens the door. Afterwards, though, I very often did not go to the places where I was invited. Or if I went I created a scandal which immediately drew attention to me, whereupon I instantly disappeared. But to me, snobbery, especially in the Surrealist period, was actually a strategy, because apart from René Crevel I was the only one who went out and was received in society. The other Surrealists did not know this *milieu*, because they were not accepted among them. With them I could always jump up and say: "I have to go to a dinner party in town," leaving them to suppose or predict (as everyone knew the next day, and it was even better that they should hear it through intermediaries) that it was a dinner party at the Faucigny-Lucinges' or with people they considered to be "forbidden fruit" because they were not invited by them. Directly afterwards, when I arrived at my host's house, I would

1. Narcisse Monturiol, a compatriot of Dalí's, born at Figueras and the inventor, it is said by some, of the submarine.

practise another type of snobbery that was still more pointed. I would say: "I'll have to leave straight after the coffee to see the Surrealist group," which I represented as a group much more difficult to get into than the aristocracy, than all the people they knew, since the Surrealists sent me insulting letters and considered the upper class to be idiots who understood nothing. At that time snobbery meant being able to say all of a sudden: "Listen, I'm going to the Place Blanche where there's a very important meeting of the Surrealist group." That created a great effect. On the one hand, I had the society people who were very curious that I should be going somewhere they could not go, and on the other the Surrealists. For myself, I always went to those places where one group or the other could not go. Snobbery consists in being able to put oneself in a position where others are not admitted, which results in a feeling of inferiority among the others. In all human relationships, there is a way of completely dominating the situation. And that was my policy with regard to surrealism. Something else should be added: I was incapable of taking part in ordinary gossip, and I did not know who was not on speaking terms with whom. Like the comedian Harry Langdon, I was always going somewhere I should not have gone. For instance, the de Beaumonts were angry with the Lopezes because of me and my film *L'Age d'Or*. Everybody knew they had fallen out and neither acknowledged nor saw each other because of me. But I, Dalí, imperturbable, went to visit the de Beaumonts and after that I went to see the Lopezes, without knowing anything about these quarrels or, when I knew, not paying them the slightest attention. It was the same thing between Coco Chanel and Elsa Schiaparelli, who were waging a civil war of fashion. I lunched with the former, had tea with the latter, and at night dined with the former. All this created great whirlpools of jealousy. I am one of the rare people who have lived in the most paradoxical circles, utterly closed to one another, and who came and went in them as he liked. I did it out of pure snobbery – that is, out of a frenzy to be seen constantly, in all the most inaccessible circles.'

The young man looked at me with eyes as round as those of a fish.

'What else did you want to know?' I asked him.

'It's your moustache. It is no longer as it was the first day I saw you.'

'It oscillates constantly, and it is never the same two days in a row. At the moment it is a bit decadent, because I mistook the time of your arrival by an hour. It has not started work yet. It has just awakened from a dream, from oneiric life.'

Upon reflection these words appeared to me banal for Dalí and created a dissatisfaction inside me which inspired me to a unique invention. I said:

'Wait!'

And I ran out to paste two vegetable fibres on to the points of my moustache. These fibres have a strange propensity for curling and uncurling continually. When I came back I showed this phenomenon to the young man. I had just invented the radar moustache.

Criticism is a sublime thing. It is worthy only of geniuses. The one man who could write a pamphlet about criticism is me, because I am the inventor of the paranoid-critical method. And I have done it.[2] But there, too, as in this diary, as in my *Secret Life*, I have not told all, and I have been careful to keep in reserve certain explosive rotten pomegranates, and if, for instance, I am asked who is the most mediocre person that ever existed, I shall say Christian Zervos. If they tell me that Matisse's colours are complementary, I shall answer that it is true that all they ever do is to pay one another compliments. And then I shall repeat that it might be a good idea to pay some attention to abstract painting. Because it has become abstract its monetary value too will very soon become abstract. There is a gradation in the misery of non-figurative painting: first there is abstract art, which looks so sad; then, what is even sadder, an abstract painter; the sadness turns into misery when one comes face to face with an admirer of abstract painting; but still worse and more sinister is the critic of abstract painting, the expert. Sometimes something ghastly happens: all the critics are unanimous about something being very good or very bad. Then you can be sure that whatever they say is false. One must be the greatest of dolts to insist that if hair turns white, it is quite natural for *papiers collés* to turn yellow.

I have called my pamphlet *The Cuckolds Of Old Modern Art*, but I have not said in it that the least magnificent cuckolds of all are the dadaist cuckolds. Old, white-haired, but still extremely anti-conformist, they passionately love receiving gold medals, from some *biennale* or other, for a piece of work assembled with the very greatest desire to displease everybody. All the same, there are cuckolds even less magnificent, if that is possible, than these old men: the cuckolds who gave the sculpture prize to Calder. The last-named was not even a dadaist, but everybody thought so, and nobody thought of telling him that the least one can ask of a piece of sculpture is not to move!

the 13th

A journalist comes from New York to ask me what I think of Leonardo's *Mona Lisa*. I tell him:

'I am a very great admirer of Marcel Duchamp, who happens to be the man who has made those famous transformations on the face of the *Gioconda*. He drew a very small moustache on her, a moustache that was itself Dalínian. Below the photograph he added in very small letters which were only just legible: "L.H.O.O.Q." "*Elle a chaud au cul!*" ("She's got a red-hot arse.") For myself, I have always admired that attitude of Duchamp's, which at the time amounted to an even more important question: whether or not the Louvre

2. Dalí had just written, while crossing the Atlantic on the *S.S. America* on April, his terrible pamphlet: *The Cuckolds Of Old Modern Art*, published by Fasquelle, 1956.

should be burned down. At that time, I was already a fervent admirer of ultra-retrograde painting, incarnated by the great Meissonier, whom I have always considered to be a painter very superior to Cézanne. And of course I was one of those who said that the Louvre should not be burned down. Up to now, I see that my view on the subject has been taken into consideration: the Louvre has not been burned down. It is obvious that if a sudden decision is taken to burn it down, the *Gioconda* must be saved and if need be even transported with all dispatch to America.[3] And not only because she is psychologically very fragile. Throughout the world, there exists an absolute Giocondolatry. Many people have attacked the *Gioconda*, notably some years ago when stones were thrown at her – a perfect example of a flagrant case of aggression against one's own mother. Knowing all Freud thought about Leonardo da Vinci, all that the latter's art kept hidden in his subconscious, it is easy to deduce that he was in love with his mother when he painted the *Gioconda*. Without realising it, he painted someone who has all the sublimated maternal attributes. She has big breasts, and she looks upon those who contemplate her in a wholly maternal way. At the same time, she smiles in an equivocal manner. Everybody has seen, and can still see today, that there was a very decisive element of eroticism in that equivocal smile. So, what happens to the poor wretch who is possessed by an Oedipus complex – that is, the complex of being in love with his mother? He goes into a museum. A museum is a house open to the public. In his subconscious it is a brothel. And in this brothel he sees represented the prototype of the image of every mother. The agonising presence of his mother gives him a tender look and an equivocal smile and drives him to a criminal act. He commits matricide by picking up the first thing that comes to hand, a stone, and destroying the painting. It is a typical piece of paranoiac aggression...'

On leaving the journalist said to me: 'It was worth the trip!'

I should think it was worth the trip! I watched him climbing the hill, deep in thought. As he walked, he bent down to pick up a stone.[4]

3. In 1963, it looked as if Dalí had been heeded. The *Gioconda* travelled to America. Yet no-one took advantage of the situation to burn down the Louvre, and when she returned the *Mona Lisa* found her house intact.

4. In *Art News* for March, 1963, Dalí returned to this theme in even more detail, suggesting that anyone who could give a different explanation of the attacks suffered by the *Mona Lisa* should cast the first stone at him. He would pick it up, he said, in order to continue building Truth.

September

the 2nd

I receive a telegram from Princess P., announcing that she is arriving tomorrow. I suppose she will be bringing the 'Chinese masturbatory violin' which her husband, the Prince, promised to bring me back as a present from his last trip to China. After dining, under a sky favourable to all places of cosmic grandeur, I dreamed of the Chinese violin fitted with a vibratory appendage. This appendage is designed to be inserted first of all in the anus, but at a later and more important stage in the cunt. When it is well and truly inserted, an expert musician starts drawing the bow across the strings of the violin, and naturally he does not just play anything, but follows a score written expressly for masturbatory purposes. By playing in judicious little flurries followed by vibratory lulls amplified by the appendage, the musician makes the wench swoon at the exact moment that he reaches the notes of ecstasy in the score.

Deeply absorbed in erotic reveries, I listen only vaguely to the conversation of three people from Barcelona who, of course, are still trying to listen to the music of the spheres. They tell each other the story of the star that has been out for millions of years and whose light we still keep seeing, as it travels for millions of light years, etc., etc., etc.

As I cannot bring myself to share any of their 'feigned' stupefactions, I tell them that nothing that occurs in the universe astonishes me, and this is entirely true. Upon which one of these people from Barcelona, a very well-known watchmaker, says to me, not being able to stand this any longer:

'Nothing of all this astonishes you! All right. But let us imagine something. It is now midnight and on the horizon a vague light begins to appear, heralding the dawn. You are looking intensely, and all of a sudden you see the sun come up. At midnight! Would not that at least astonish you?'

'No,' I answer, 'that would not astonish me in the slightest.'

The watchmaker from Barcelona exclaimed: 'Well, I would be astonished! And so much so that I should think I had gone mad.'

Here Salvador Dalí produced one of those monumental quips of which he alone has the secret:

'With me it is the opposite! I should think it was the sun that had gone mad.'

the 3rd

The Princess arrives without the Chinese anal violin. She claims that ever since I conceived of the famous swooning by vibrations in the anus, she has been

afraid of crossing the frontier with it and perhaps having to explain to the customs men how the instrument works. In place of the violin she has brought me a china goose which we shall put in the centre of the table. The goose opens up by means of a lid on its back. I tell the princess divine things about the goose game that only Dalí knows, but at the same moment a sudden phantasy takes possession of me. I imagine that I shall have the neck of this goose sawn off by the same sculptor that I employed to add genitals to the torso of Phidias. At dinner-time I shall then enclose a living goose in the china one. Only the head and neck of the living goose inside will be visible. If it makes a noise we could make a gold hook to close its beak. Then, I think of an orifice that resembles the anus of the goose. During the most melancholy *petits fours* a Japanese type in a kimono will enter the room with a Chinese violin and vibratory appendage which he will insert into the anus of the goose. By playing after-dinner music, he will provoke the swooning of the goose, which will take place amid the conversation of the dinner guests...

The scene will be illuminated by very special candlesticks. Live sandwich monkeys will be locked into halves of silver monkeys, in such a way that the only real and living part of the candelabra monkeys will be their faces, gasping and contorted by the sculpted torture. I shall also take an infinite delight in seeing the exasperated movement of their tails as a result of the same constraint. They will strike the table convulsively while my sandwich monkeys, greater fools than any other species of monkey, will be forced to bear with dignity the utterly tranquil candles.

At that very moment I am illumined by a Jovian flash of lightning: a mockery two trillion times greater than the mockery of the monkeys would be to make a fool of the king of beats, the lion. Yes, of course – I'll take a lion and cover him with beautiful straps of polished leather from Hermès in Paris. These straps will be used to keep in place around his body some ten cages filled with ortolans and other delicious titbits, but in such a way that the lion can never succeed in catching any of the sybaritic delicacies with which he is so profusely decorated. With the aid of a set of mirrors he will observe the food, which will make him languish, languish till death ensues. Edifying agony, really, which could be of incomparable subversive and moral value to all those who have followed each moment of such an exemplary death.

The feast of the lion starved to death should be celebrated every lustrum by the councils of all small villages, five days after Epiphany, to serve as a cybernetic programming for the great modern, industrial cities.

the 4th

This fourth of September (September Septembered, moons and lions of May), something happened at four o'clock, one of those phenomena that I attribute to God. While looking for a picture of a lion in a history book, from out of the page showing a lion, a small black-edged envelope fell to the ground. I opened

it. It was a visiting card from Raymond Roussel, thanking me for sending him one of my books.[5] Roussel, highly neurotic, committed suicide at Palermo just when, having given myself to him body and soul, I was suffering such anguish that I thought I was going mad. I was suddenly overcome with agony at this memory, and I fell on my knees, thanking God for the warning.

While on my knees, I perceive through the window Gala's yellow boat arriving at the jetty. I go out and run down to embrace my treasure. It is God, too, who sends her to me. She looks more than ever like the Metro-Goldwyn-Mayer lion. And never have I felt so much like eating her. But all notion of the lion's death agony has disappeared. I ask Gala to spit on my forehead, which she immediately does.

the 5th

I clumsily knocked myself very hard on the head. Immediately I spat several times, remembering that my parents used to say that this helped counteract the effect of the blow. Pressing gently on a swelling produces a pain that is as sweet and as moral as the melancholy greengages of August 15th.

the 6th

We drove down to the market at Figueras, where I bought ten crash helmets and Gala bought chairs of different heights. The helmets are made of straw like those worn by small children to protect them when they fall. Back home, I put each crash helmet on a chair. The semi-liturgical look of this arrangement gave me a slight erection. I went up to my studio to pray and thank God. Dalí will never be mad. What I had just done was the most harmonious of all possible marriages. And for those – psychoanalysts and others – who will write volumes on the triumphant wisdom of the delirium of this first sacred week in September, I should add, to make everybody even happier, that each of the chairs bore a small cushion stuffed with goose feathers. Woe to him who has not yet seen in each of these goose feathers the ghost of a true cybernetic anal violin, the Dalínian machine for thinking of the future.

the 7th

Today is Sunday. I wake up very late. When I look out of the window I see stepping out of a boat one of the Negroes who are camping in the neighbourhood. He is covered in blood and carries in his arms one of our swans which is wounded and dying. A tourist had harpooned it, thinking he had discovered a rare bird. This sight affords me a strangely pleasant sadness. Gala

5 Raymond Roussel (1877–1933), greatly admired by the Surrealists, the author of *Impressions d'Afrique*, *La Doublure*, *Locus Solus*, etc.

comes running out of the house to embrace the swan. At that moment a noise is heard which makes us all jump. With a great deal of noise, a truckload of anthracite for the furnace is being dumped. That truck is the catalytic agent of the myth. In our day one can divine the actions of Jupiter, if one is watchful, in the unexpected presence of trucks which are so big that you cannot help seeing them.

the 8th

Friends telephoned me that King Umberto of Italy is coming to visit us. I have ordered the *sardañas* orchestra to come and play in his honour. He will be the first man to walk on the road that I am having re-whitewashed. This road is lined with pomegranate trees. In the afternoon I went to sleep thinking of the arrival of the king who will thread two jasmines at the points of my moustache, through their tiny holes. Then I dreamed an unforgettable dream. A swan is filled with explosive pomegranates which make it explode. I notice the smallest visceral fragments, as in a stroboscopic film. The flight of each feather follows the shape of diminutive flying violins.

On awakening, I knelt down and thanked the Virgin for this euphoric dream which will certainly become aureophic.

the 9th

the 10th

I must tell everything, even if it is incredible. My personality excludes any possibility of jokes or mystifications because I am a mystic, and mystics and mystifications are formal opposites by the law of communicating vessels.

The other morning an old friend of my father's, who wants me to identify an old painting of mine that is in his family's possession, came to see me. I told him that the painting was authentic. It surprised him that I should be able to authenticate it like that, without even seeing the canvas. But it was enough for me to see him. He insisted on showing me the canvas, which had been left in the hall.

'Let's have a look at it ... I have left it beside the stuffed bear.'[6]

'Impossible,' I said, 'His Majesty the King is busy changing his bathing costume just behind the bear.'

Which was perfectly true.

'Oh,' he answered with a hint of reproof in his voice, 'oh, if you weren't the greatest practical joker on earth, you'd be the greatest painter!'

Yet I had only told him the strictest truth.

6. In the entrance-hall of his house at Port Lligat, Dalí has set up in a corner a stuffed bear which he has covered with jewels.

Now this reminds me of my visit to His Holiness Pius XII two years ago. One morning in Rome I ran down the steps of the Grand Hotel as fast as I could, armed with a strange box tied round with string and sealed with lead. This box contained one of my paintings. In the foyer René Clair was sitting reading the paper. He lifted his eyes, those eyes that are always sceptical, with dark circles under them caused, as everyone knows, by the incurable wound of Cartesian deception. He said to me:

'Where are you off to in such a hurry, at this time of day, and with all those strings?'

I answered curtly and with maximum dignity:

'I'm going to see the Pope and then I'm coming back. Wait for me here.'

René Clair did not believe this for a moment, and said in a theatrical tone, affecting the greatest seriousness:

'Please give him my respectful regards.'

Exactly three quarters of an hour later I was back. René Clair was still there, sitting in the foyer. With a defeated look he showed me the paper he was reading. In the meantime, just after my departure, he had discovered a news item from the Vatican announcing the visit I had just made to the Pope. The box I had carried contained the effigy of Gala as the Madonna of Port Lligat, which I had shown to the sovereign pontiff.

But what René Clair never knew was that among the three hundred and fifty reasons for my visit, number one was an effort to obtain an authorisation to marry Gala in church. This was a difficult thing because her first husband, Paul Eluard, was still, to everyone's joy, alive.

Yesterday, the 9th of September, I took stock of my genius to see whether it is growing, the figure nine being the last cube of a hypercube. Things have gone that far! And today I received a letter telling me that an American collector possesses the copy of *La Conquête De l'Irrationnel* which I presented to Adolf Hitler, with my sign of the cross as a dedication.

Hence I have every reason to believe I can recuperate the magic talisman that made Hitler lose the war or, at the very least, the final battle.

Moreover, have I not surmounted by an angelic stratagem (that is, by a stroke of genius) the bare-faced threats of my madness culminating in the philosophic and euphoric dream of the explosive swans?

Yesterday I received the visit of a king, and I have firmly resolved to marry the supremely beautiful Helen Gala in order once again to fool René Clair,[7] who is the friendly symbol of the Voltairean Saint-Tropez.

The cube number nine of my plenitude of life's density is greatly superior to the nine of last year. Comparing them, indeed, I see no king, no European war already won. Only the courage was superior! Instead of René Clair, there was an unmentionable name ending in '*oie*' (goose)!

7. The marriage was to be celebrated in 1958.

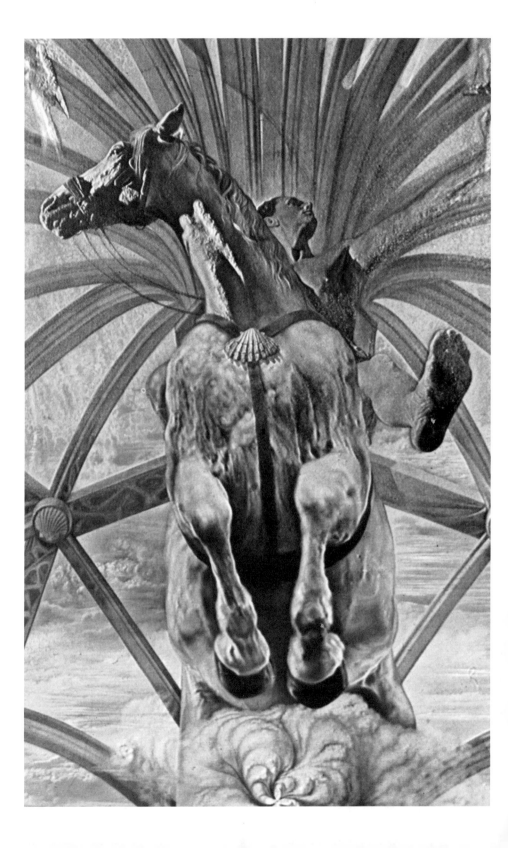

1957

May

Port Lligat, the 9th

On awakening I kiss Gala's ear to feel with the tip of my tongue the thickness of the minuscule moulding on the lobe. At that moment I feel, all mixed in with my saliva, Picasso. Picasso, who is the most vital man I have ever known and who possesses a birthmark on the lobe of his left ear. That mark, slightly more olive than dark gold and protruding very very slightly, is in exactly the same spot as the one on my wife, Gala. It could be thought of as its exact copy. Very often, when I think of Picasso, I caress that slight bulge in the corner of Gala's left ear. And this happens often, because Picasso is the man of whom I have thought most often, after my father. Both are more or less the William Tells of my life. It is against their authority that I have risen in heroic revolt, unhesitatingly, ever since my earliest adolescence.

That birthmark of Gala's is the only living part of her body that I can completely envelop with my two fingers. It reassures me in an irrational way as to her phoenixological immortality. And I love her more than my mother, more than my father, more than Picasso, and even more than money!

Spain has always had the honour of offering the world the highest and most violent contrasts. These contrasts in the twentieth century are incarnated in the two personalities of Pablo Picasso and your humble servant. The most important things that can happen to a contemporary painter are:

1. To be a Spaniard;
2. To be called Gala Salvador Dalí.

These two things have happened to me. As my Christian name Salvador indicates, I am destined to do nothing less than to save modern painting from sloth and chaos. I am called Dalí, which means 'desire' in Catalan, and I have Gala. Picasso certainly is Spanish, but of Gala he has only a biological shadow on the corner of his ear, and he is called Pablo, like Pablo Casals, like the Popes – that is to say, he has a name like everybody else's.

In society, in an intermittent but monotonous way, I meet very elegant (and therefore moderately pretty) women, with the coccyx bones almost monstrously developed. For several years, generally speaking, such women have been dying to get to know me personally. The conversation regularly goes like this:

COCCYX WOMAN
Of course I know you by name.

I, DALÍ
So do I.

COCCYX WOMAN
You have noticed perhaps that I haven't stopped staring at you. I think you are fascinating.

I, DALÍ
So do I.

COCCYX WOMAN
Don't flatter me! You haven't even noticed me.

I, DALÍ
I am speaking of myself, Madam.

COCCYX WOMAN
I keep wondering how you make your moustache point upwards.

I, DALÍ
Dates!

COCCYX WOMAN
Excuse me?

I, DALÍ
Dates. Yes, dates, the fruit of the date palm. At dessert, I ask for dates, I eat them, and before washing my fingers in the bowl, I run them lightly over my moustache. That is sufficient to make it stand up.

COCCYX WOMAN
Oh!!!!!!

I, DALÍ

Another advantage is that the sugar from the dates inevitably attracts the flies.

COCCYX WOMAN
How horrible!

I, DALÍ
I adore flies. I am only happy in the sun, naked and covered with flies.

COCCYX WOMAN
(already convinced, by my tone of rigorous authenticity, of the truth of all I have said)
But how is it possible to love being covered with flies? It's so dirty!

I, DALÍ
I hate dirty flies. I only love the very cleanest flies.

COCCYX WOMAN
I wonder how you can tell clean flies from dirty ones.

I, DALÍ
I can tell immediately. I cannot bear the dirty city fly or even the village fly with its swollen belly, yellow as mayonnaise, its black wings that look as if they had been dipped in some lugubrious necrophilic mascara. I love only the cleanest flies, super-gay, dressed in little grey alpaca suits from Balenciaga, glittering like a dry rainbow, precise as mica, with granite eyes and with bellies of noble Naples yellow, such as the marvellous little olive flies of Port Lligat, where nobody lives except Gala and Dalí. These little flies always have the grace to sit on the oxidised silver side of the olive leaf. They are the fairies of the Mediterranean. They brought inspiration to the Greek philosophers, who spent their lives in the sun, covered with flies... Your dreamy expression already leads me to believe that you are won over by the flies... To finish what I was saying, I must tell you that the day I find my thoughts are disturbed by the flies that cover me, I shall know this means that my ideas do not have the power of that paranoid stream which is the proof of my genius. On the other hand, if I do not notice the flies, it is the surest proof that I have the spiritual situation entirely under control.

COCCYX WOMAN
Really, everything you say seems to have a meaning! So it is true that your moustache is an antenna through which you receive your ideas?

At this question the divine Dalí flies off and surpasses himself. He embroiders all his favourite themes, embroiders the lace of Vermeer, so delicately, so hypocritically, enticingly and gastronomically that there is nothing left of the

coccyx woman but the Cuban coccyx. That is to say – as you will already be thinking – the pure cuckolding concubine who, through my cybernetic procedure, deceives her male, the *concubin* of the *concubite*.

the 11th

I have already remarked, when describing my meeting with Freud, that his skull looked like a Burgundy snail.[1] The corollary is obvious: if you want to eat his thoughts you have to pick them out with a needle. Then they come out whole. If not, they break and there is nothing you can do about it, you will never get anywhere. Today while reminding you of Freud's death, I shall add that the Burgundy snail, outside its shell, is one of the things that look quite stunningly like a painting by El Greco. Also, an El Greco and the Burgundy snail are two things that have no real taste at all. From a simple gastronomical point of view, they are less succulent than a rubber eraser.

All those who love snails are already crying out in protest. I must go into more detail. Even if the snail and the El Greco have no taste in themselves, they do possess and offer us that extremely rare and quasi-miraculous virtue of 'transcendent gustative mimicry', which consists in effacing themselves and providing a meeting ground (because of their own insipidity) for all the flavours contributed by the condiments they are eaten with. Both are magic vehicles for the bringing together of all tastes. And that is why each of the flavours with which the El Greco and the Burgundy snail are prepared can attain its *plain chant* distinctly and symphonically.

If the snail had a taste of its own, would man's palate ever have been able to obtain such Pythagorian knowledge of what is represented in Mediterranean civilisation by that livid crescent, moonlike and agonised with ecstatic euphoria – the clove of garlic? The garlic that illuminates, so as to bring tears to the eyes, the cloudless sky of the insipid snail's tastelessness.

In the same way the insipidity of El Greco is in itself as insubstantially tasteless as that of the Burgundy snail without condiments. But – watch out! – like the snail, El Greco possesses that vehicular virtue, that unique power to render all flowers orgiastic. When he left Italy, he was more golden, more sensual and fat than a 'merchant of Venice', but look at him when he arrives in Toledo and suddenly soaks up all the perfumes, substances and quintessences of the ascetic and mystic spirit of Spain. He then becomes more Spanish than the Spaniards because, masochistic and more insipid than a snail, he is perfectly suited to become the receptacle, the passive flesh fit to receive the stigmata of the sephardic knights crucified by nobility. That is the origin of his blacks and

1. In *My Secret Life*, Dalí touches again upon a question that was then very thorny. His detractors have long claimed that he never met Freud. But Fleur Cowles in her book *Dalí, The Life Of A Great Eccentric*, has been able to prove by a letter indisputably written by Freud, that the painter and the doctor indeed met in London at the beginning of the summer of 1938.

greys with the unique flavour of Catholic faith and the militant metals of the soul, that super-garlic in the shape of a waning moon of agonised Lorca silver. It is the very moon that lights the views of Toledo and the dappled folds and drapes of his *Assumption*, one of El Greco's most elongated figures, so similar in every respect to the curving outline of a spicy Burgundy snail if you observe it carefully as it unrolls and stretches on the point of your needle! All you need to imagine is that the force of gravity which draws it towards the earth is, if you reverse the image, the force that makes it fall towards heaven!

Such, in a single visual image, is the evidence I advance for my thesis which is not yet sustained and according to which Freud is nothing but a 'great mystic upside down'. Because if his brain, heavy and spiced with all the viscosities of materialism, instead of depressively hanging, pulled down by the force of gravity of the most subterranean cloacae of the depths of the earth, were by contrast drawn towards the other vertigo, that of the celestial abysses, that brain, I repeat, instead of looking like the semi-ammoniacal snail of death, would exactly resemble the glorious *Assumption* painted by El Greco which I mentioned a few lines back.

Freud's brain, one of the most savoury and important of our age, was *par excellence* the snail of terrestrial death. For that matter, in it resided the essence of the constant tragedy of the Jewish genius which is always deprived of that primordial element, beauty – a condition necessary to the complete knowledge of God, Who must be supremely beautiful.

It seems that without realising it I drew Freud's terrestrial death in the pencil portrait I did of him a year before his death. My special intention had been to create a purely morphological drawing of the genius of psychoanalysis, instead of trying to do the obvious portrait of a psychologist. When the portrait was finished, I begged Stefan Zweig, who had been my go-between with Freud, to show it to him, and then I anxiously awaited whatever remarks he might make. I had been extremely flattered by his exclamation at the time of our meeting: 'I have never seen such a perfect prototype of a Spaniard! What a fanatic!'

He had said this to Zweig after scrutinising me for a long time in a terribly intense manner. All the same, I only received Freud's answer four months later when, accompanied by Gala, I again met Stefan Zweig and his wife at a lunch in New York. I was so impatient that I did not wait for the coffee before asking what had been Freud's reaction to seeing my portrait.

'He liked it very much,' Zweig told me.

I asked for more details, eager to know if Freud had made any concrete observation or the least comment that would have been infinitely precious to me, but Stefan Zweig seemed to me to be evasive or distracted by other thoughts. He claimed that Freud had greatly appreciated 'the delicacy of the features' and then plunged back into his *idée fixe*: he wanted us to come and join him in Brazil. The voyage, he said, would be marvellous and would bring a fruitful change into our lives. That idea and the obsession wrought in him by

the persecution of the Jews in Germany were the unending *leitmotifs* of the monologue of our meal. It would seem that I really had to go to Brazil in order to survive. I protested that I hated the tropics. A painter cannot live, I asserted, unless surrounded by the grey of the olive trees and the red of the noble soil of Siena. My horror of the exotic upset Zweig to the point of tears. Then he reminded me of the size of the Brazilian butterflies, but I gnashed my teeth: butterflies everywhere are always too big. Zweig was in despair. He seemed to think that only in Brazil could Gala and I be perfectly happy.

The Zweigs left us their address, which they wrote down meticulously. He could not believe that I would remain so recalcitrant and headstrong. You would really have thought that our arrival in Brazil was a question of life or death for that couple!

Two months later we learned about the double suicide of the Zweigs in Brazil. They had decided upon that suicide in a moment of perfect clairvoyance, after writing to each other.

Butterflies that are too big?

Only when I read the concluding chapter of Stefan Zweig's posthumous book, *The World of Tomorrow*, did I finally learn the truth about my drawing. Freud had never seen his own portrait. Zweig had piously lied to me. According to him, my portrait so strikingly forecast Freud's impending death that he did not dare show it to him, fearing to upset him unnecessarily, and knowing him to be already very sick with cancer.

Without hesitation, I place Freud among the heroes. He dispossessed the Jewish people of the greatest and most influential of all its heroes – Moses. Freud has shown that Moses was an Egyptian, and in the foreword to his book on Moses – the best and most tragic of his books – he warns his readers that proving this has been his hardest and most ambitious task, but also the most corrosively bitter one!

Finished are the big butterflies!

November

Paris, the 6th

Joseph Fort has just brought the first copy of the *Quixote* illustrated by me in a technique that, since I inaugurated it, has triumphed the world over, even though it is really inimitable. Once again, Salvador Dalí has gained an imperial victory. It is not the first time. At the age of twenty, I made a bet that I would win the Royal Academy of Madrid's Grand Prix by painting a picture that I would execute without at any time touching the canvas with a brush. Of course I won the prize. The painting depicted a naked and virginal young woman. Standing at a distance of more than three feet from my easel, I projected the colours which splattered on to the canvas. The extraordinary thing was that not a spot was out of place. each splatter was immaculate.

It was a year ago to the day that I won the same bet in Paris. During the summer, Joseph Foret landed at Port Lligat with a cargo of heavy lithographic stones. He insisted that I illustrate a *Don Quixote* on those stones. As it happened, at that time I was against the art of lithography for aesthetic, moral and philosophical reasons. I considered the process was without strength, without monarchy, without inquisition. In my view, it was nothing but a liberal, bureaucratic and soft process. All the same, the perseverance of Foret, who kept bringing me stones, exasperated my anti-lithographic will to power to the point of aggressive hyper-aestheticism. While in this state, an angelic idea made the jaws of my brain gape. Had not Gandhi already said: 'The angels dominate situations without needing a plan'? Thus, instantly, like an angel, I dominated the situation of my *Quixote*.

I might not be able to shoot a bullet from an arquebus against paper, without tearing it, but I could shoot against a stone without breaking it. Persuaded by Foret, I wired to Paris to have an arquebus ready as soon as I arrived. My friend the painter Georges Mathieu presented me with a very precious fifteenth-century arquebus whose breech was inlaid with ivory. And on the 6th of November, 1956, surrounded by a hundred sheep sacrificed in a holocaust to the very first parchment copy, I fired, on board a barge on the Seine, the world's first lead bullet filled with lithographic ink. The shattered bullet opened the age of 'bulletism'. On the stone, a divine blotch appeared, a sort of angelic wing whose aerial details and dynamic strength surpassed all techniques ever employed before. In the week that followed I gave myself up to new and fantastic experiments. In Montmartre, before a delirious crowd, surrounded by eighty girls on the verge of ecstasy, I filled two hollowed-out rhinoceros horns with bread crumbs soaked in ink, and then calling upon the memory of my William Tell, I smashed them on the stone. The result was a

miracle for which God should be thanked: the rhinoceros horns had drawn the two open arms of a windmill. Then a double miracle: when I received the first proofs a bad 'take' had left spots on them. I believed it my duty to incorporate and accentuate those spots in order to illustrate paranoiacally the whole electric mystery of the liturgy of this scene. Don Quixote encountered in the outside world the paranoiac giants he carried within himself. In the scene of the wineskins, Dalí recognised the hero's chimerical blood and the logarithmic curve that swells Minerva's forehead. Better still, Don Quixote, being a Spaniard and a realist, does not need an Aladdin's lamp. It is enough for him to take an acorn between his fingers, and the Golden Age is reborn.

As soon as I returned to New York, the television producers were fighting over my efforts at 'bulletism'. As for me, I slept all the time in order to find in my dreams the most effective and accurate way of firing ink-filled bullets so as to arrange the holes mathematically. With armoury specialists from the New York Military Academy, I woke every morning to the sound of arquebus shots. Each explosion gave birth to a complete lithograph which I only had to sign for collectors to tear it from my hands at fabulous prices. Once again I perceived that I had been in advance of the ultimate scientific discoveries when I learned, three months after my first arquebus shot, that learned men used a gun and bullets like mine to try and discover the mysteries of creation.

In May of this year I was again in Port Lligat. Joseph Foret was waiting for me with the trunk of his car full of new stones. New blasts of the arquebus once more gave birth to *Don Quixote*. Overwhelmed by suffering, he was transfigured into an adolescent whose plaintive sadness did justice to his blood-crowned head. In a light worthy of Vermeer filtering through Hispano-Mauresque window niches, he read his tales of courtly love. With a tube of 'silly putty' like those that American children play with, I created spirals along which the lithographic ink ran: it was an angelic shape with a gilt fuzziness, the break of day. Don Quixote, paranoid microcosmos, merged into and then emerged from the Milky Way, which is nothing other than the path of Saint James.

Saint James was watching over my work. He manifested himself on August the 25th, his name day, when, in the course of my experiments, I achieved an explosion that will remain forever glorious in the history of morphological science. It has been etched for eternity in one of the stones that Joseph Foret, with his saintly insistence, kept offering assiduously to the lightning strokes of my imagination. I took an empty Burgundy snail and filled it right up with lithographic ink. Next I slid it into the barrel of the arquebus and aimed at the stone at very close range. When I fired, a volume of liquid perfectly espousing the curve of the snail's spirals produced a splatter which after a long analysis I found to be increasingly divine, as if in fact there was nothing less than a state of 'pre-snailian galaxy' at the supreme moment of its creation. Saint James's Day will therefore go down in history as the day that witnessed the most categorical Dalínian victory over anthropomorphism.

The day following that blessed day, there was a storm and it rained tiny

toads which were at once plunged into the ink and formed the pattern of Don Quixote's embroidered costume. These toads created the batrachian humidity opposed to the dazzling dryness of the high plains of Castile which reigned in the hero's head. Chimera of chimeras. Nothing was chimera any longer. Sancho appeared, while Don Quixote touched with his finger the dragons of Doctor Jung.

Today, when Joseph Foret has just laid on my table the very first copy, I can exclaim: 'Bravo Dalí! You have illustrated Cervantes. Each of your explosions contains in truth a windmill and a giant. Your work is a bibliophilic giant, and it is the pinnacle of all the most fertile lithographic contradictions.'

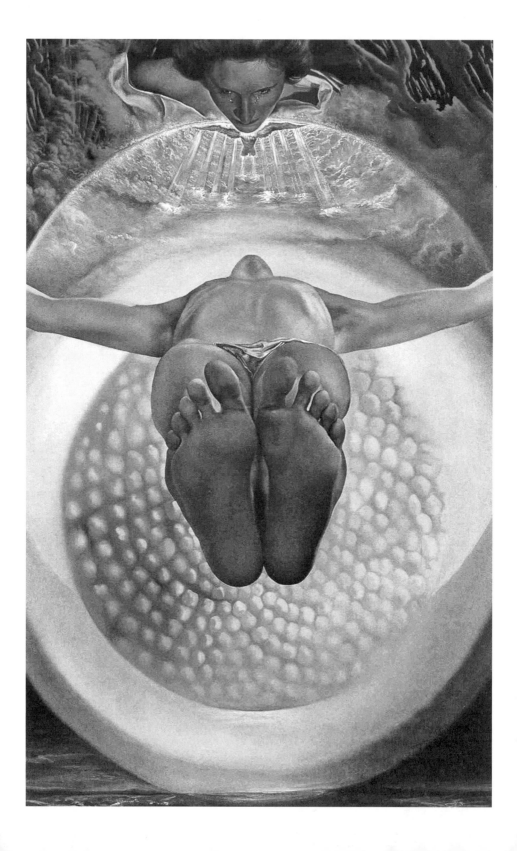

1958

September

Port Lligat, the 1st

It is difficult to hold the world's interest for more than half an hour at a time. I myself have done so successfully every day for twenty years. My motto has been: 'Let them speak of Dalí, even if they speak well of him.' I have been successful for twenty years, to the extent that the papers publish the most incomprehensible news items of our time, sent by teletype.

PARIS. Dalí gave a lecture at the Sorbonne on Vermeer's *Lacemaker* and the rhinoceros. He arrived in a white Rolls-Royce containing a thousand white cauliflowers.

ROME. In the torchlit gardens of the Princess Pallavicini, Dalí was reborn, rising all of a sudden from out of a cubic egg covered with magic inscriptions by Raimondo Lulio, and delivered an explosive oration in Latin.

GERONA, SPAIN. Dalí has just contracted his secret liturgical marriage with Gala at the Hermitage of the Virgin with the Angels. He declared: 'We are now archangelical beings!'

VENICE. Gala and Dalí, dressed as eighteen-foot-high giants, came down the steps of the Beistegui Palace and danced with the crowd cheering them in the Piazza.

PARIS. In Montmartre, opposite the Moulin de la Galette, Dalí illustrated his *Don Quixote* with arquebus shots against lithographic stone. He declared: 'Mills make flour – I am now going to use flour to make mills.' And filling two rhinoceros horns with flour and bread crumbs soaked in lithographic ink, he fired them, achieving what he had just announced.

MADRID. Dalí made a speech inviting Picasso to return to Spain. He began by proclaiming: 'Picasso is a Spaniard – so am I! Picasso is a genius – so am I! Picasso is a Communist – neither am I!'

GLASGOW. Dalí's famous *Christ Of Saint John Of The Cross* has just been bought by unanimous agreement of the municipality. The price paid for this work of art has provoked a great deal of indignation and controversy.

NICE. Dalí has announced he is to make a film with Anna Magnani, *The Flesh Wheelbarrow*, in which the heroine falls madly in love with a wheelbarrow.

PARIS. Dalí walked across the city carrying in a procession a loaf of bread fifteen yards long. The bread was left on the stage of the Etoile Theatre, where Dalí delivered an hysterical oration on Heisenberg's 'cosmic glue'.

BARCELONA. Dalí and Luis Miguel Dominguin have decided to hold a Surrealist bullfight, at the end of which a helicopter, dressed as an Infanta in a dress by Balenciaga, will carry the sacrificed bull into the sky and then set it down in the sacred mountains of Montserrat to be devoured by vultures. At the same time, on an improvised Parnassus, Dominguin will crown Gala, disguised as Leda, at whose feet Dalí will hatch naked out of an egg.

LONDON. At the planetarium the stars are being rearranged as they were at Port Lligat at the time of Dalí's birth. He proclaims himself, according to the analysis of his psychiatrist, Dr. Roumeguère,[1] to be the incarnation with Gala of the cosmic and sublime myth of the Dioscuri (Castor and Pollux). 'Gala and I are Jupiter's children.'

NEW YORK. Dalí landed in New York dressed in a golden space-suit, inside the famous 'ovocipede' invented by him. A transparent sphere, it is a new means of locomotion based on the fantasies provoked by the intra-uterine paradises.

Never, never, never, never has an excess of money, of publicity, of success, or of popularity made me feel, even for a quarter of second, like committing suicide ... on the contrary, I love it all. Not long ago a friend who could not understand why all this hubbub does not make me suffer, asked me, tentatively:

'So you feel no suffering of any kind from all this success?'

'No!'

Then, beseechingly: 'Not even a very mild sort of neurosis?'

(His expression meant, 'out of charity'.)

'No!' I answered categorically.

Then, as he was exceedingly rich, I added: 'I can prove to you that I am willing to accept 50,000 dollars right away, without batting an eyelid,'

Everybody, especially in America, wants to know the secret of this success. It is the paranoiac-critical method that I invented thirty years ago, and that I have subsequently practised with success, though I do not yet know what it consists of. In a general way, it is the most rigorous systematisation of the most delirious phenomena and materials, thus rendering my most obsessively dangerous ideas tangibly creative. This method functions only on condition that it possesses a soft motor of divine origin, a living nucleus, a Gala – and there is only one Gala.

1. Dr. Pierre Roumeguère, of the Paris Faculty of Medicine, is, among other things, the author of a treatise *The Dalinian Mystique In The Context Of Religious History.*

So by way of a sample I am going to treat the readers of my diary to the story of one single day – that on the eve of my last departure for New York – lived according to the famous paranoiac-critical method.

At daybreak, I dreamt that I was the author of several white turds, very clean and extremely agreeable to produce. When I woke up, I said to Gala:

'Today there is going to be gold!'

For this dream, according to Freud, indicated in bald terms that I was related to the hen with the golden eggs and the legendary ass who, when his tail was lifted, would shit golden coins, without mentioning Danaë's divine diarrhoea of semi-liquid gold. As far as I was concerned, I had felt for a week that I was becoming an alchemist's crucible, and I had planned at midnight – on the last night in New York before my departure – to assemble a group of friends in the Champagne Room of El Morocco, including the four most beautiful models in town. The city was already resplendent, as if ready for the announcement of a possible Parsifal. That possible Parsifal, which I had promised myself to bring to perfection in the course of the day's events, prodigiously stimulated all my capacities for action; and my power, which was to be supreme that day, was to solve all problems expeditiously, making them click their heels in the Prussian manner.

At half-past eleven, I left the hotel with two precise aims in mind: to have an irrational type of photograph taken by Philippe Halsman, and before lunch to try and sell my painting *Saint James Of Compostela, Patron Of Spain* to the American millionaire and Maecenas, Huntington Hartford. By pure chance the lift stopped at the second floor, where I was acclaimed by a crowd of journalists who were waiting for me. I had completely forgotten that there was going to be a Press conference in the course of which I was to present my plan for a new bottle of scent. I was photographed as I was being given the cheque, which I folded and put in the pocket of my waistcoat, slightly irritated because I had no other solution except there and then to draw the bottle stipulated in the contract, which I had long since forgotten about. Without a moment's hesitation, I collected a burnt-out flash bulb from a photographer. It was ice-blue. I held it up like a precious object between my thumb and forefinger.

'Here is my idea.'

'It's not a drawing!'

'It's much better! Here is your model all ready for you! It only needs to be copied in every detail!'

I pressed the bulb down carefully on the table; it cracked imperceptibly and the base flattened out enough to stand up. I pointed out the socket, which I said would be its gold stopper. The ecstatic perfume manufacturer cries out:

'It's as obvious as Columbus's egg, but you have to think of it! Now what, *cher maître*, is the name of this unique perfume destined for the *nouvelle vague*?'

Dalí's answer comes in one word:

'Flash!'

'Flash! Flash! Flash!' everybody calls out. 'Flash!'

They catch me at the door and ask me:

'What is fashion?'

'What becomes unfashionable!'

They entreat me to launch one last Dalínian idea on what women should wear.

As I leave, I answer:

'Breasts on their backs!'

'Why?'

'Because breasts contain white milk which is capable of creating an angelic effect.'

'Are you alluding to the immaculate skin of an angel?'

'I am alluding to women's shoulder blades. If two fountains of milk are made to spout, thereby lengthening their shoulder blades, and if a stroboscopic photograph is made of the result, you will have the very "angel wings of droplets" such as Memling painted.'

Armed with this angelic idea, I set out to see Philippe Halsman, having firmly decided to recreate photographically the droplet wings that had just surprised and fascinated me.

But Halsman is not equipped for a stroboscopic photograph, and I decide there and then to photograph the capillary history of Marxism. To this purpose, I have six discs of white paper attached to my moustache, instead of my droplets. In each of the discs Halsman superimposes successively, in this order, the portraits of Karl Marx, with leonine beard and hair; Engels, with the same pilose attributes considerably diminished; Lenin, half bald, with a slender moustache and goatee; Stalin with thick hair limited to a moustache; Malenkov, clean-shaven. As I had one paper disc left, I reserved it prophetically for Khrushchev, who has a bald pate.[2] Today Halsman is pulling out what little hair he has left, especially after returning from Russia, where that photo has been one of the most acclaimed of his book *Dalí's Moustache*.

I went to Huntington Hartford, carrying in one hand the last, faceless paper disc and in the other the reproduction of my *Saint James* which I had come to show him. I had hardly stepped into the lift when I remembered that Prince Ali Khan lives on the floor above Huntington Hartford. And because of my congenital and indomitable snobbery, after a moment's hesitation, I gave the lift boy the reproduction of *Saint James* as a gift in homage to the prince. Immediately I felt a fool because I was entering Huntington Hartford's apartment not only empty-handed, but with an empty paper disc, doubly ridiculous because it was hanging from a thread. I was beginning to savour the

2. Simon and Schuster, who published Halsman's book *Dalí's Moustache*, advised Dalí to abstain from all prophecies, as the unlikely element in them might detract from the perfection of what had gone before.

absurdity of the situation, telling myself that it would turn out very well. Yes, my paranoiac-critical method was immediately to turn this delirious event into the most rewarding incident of the day. The seed of Karl Marx was already making itself heard in the future Dalínian egg of Christopher Columbus.

Huntington hartford immediately asked if I had brought the colour reproduction of my *Saint James*. I said I hadn't. He then asked if it would be possible to go to the gallery to unpack the big painting. At that very moment I decided, without knowing why, that my *Saint James* must be sold in Canada.

'It would be better if I did another painting for you, called *The Discovery Of The New World By Christopher Columbus*.'

It was like a magic word, and it *was* one! Because the then future Huntington Hartford Museum was to be erected in Columbus Circle, opposite the only monument in New York that represents Christopher Columbus – a coincidence that we discovered several months later. As I write this, my friend Dr. Colin, who is with me, stops me and asks if I have noticed that the lift in the building where the prince lives was manufactured by Dunn & Co. As a matter of fact, I was thinking of Lady Dunn either consciously or subconsciously as the buyer of my *Saint James* and it so happens that she did subsequently buy it.

I am still thankful to Philippe Halsman for refusing to put the portrait of Khrushchev in the last paper disc. I think I have a right to call it 'My Columbus Circle' now, because without it I would perhaps never have painted the cosmic dream of Christopher Columbus. As it is, the latest geographical maps discovered by Soviet historians have just proved the very thesis developed in my painting, thus making this work particularly appropriate to an exhibition in Russia. Only today a friend, Sol Hurok, is leaving with a reproduction of this picture in order to propose to the Soviet Government a cultural exchange that will unite me with two great compatriots – Victoria de Los Angeles and Andrès Segovia.

I arrive five minutes early for lunch with Gala. Before I have time to sit down, there is a phone call from Palm beach. Mr Winston Guest is on the line and asks me to paint *The Virgin Of Guadalupe* as well as a portrait of his twelve-year-old son Alexander who, I had noticed, wore his hair crew-cut like a baby chicken. When I want to go and sit down again I am called to a neighbouring table where I am asked if I will agree to make an enamelled egg in the tradition of Fabergé. This egg is destined to contain a pearl.

But I did not know whether I was hungry or feeling unwell; the feeling I had could just as well have been a mild urge to vomit as the ever-present erotic emotion (which gets keener each time) at the thought of the Parsifal that awaited me at midnight. My lunch consisted of nothing but a soft-boiled egg and some biscuits. Here again, it should be noted that the paranoiac-critical method must operate efficaciously through my paranoid-visceral biochemistry to add the necessary albumen for the hatching of all the invisible and imaginary eggs I carried throughout the afternoon over my head – eggs so similar to the

egg of Euclidian perfection that Piero della Francesca suspended over the head of the Virgin. That egg to me became the sword of Damocles, which only the teledespatched growls of the infinitely tender little lion (I speak of Gala) prevented all the time from falling and splitting my skull.

In the twilight of the Champagne Room, the erotic satellite of midnight already shone, my Parsifal, the thought of which drove me to become ever more virtuous every second. After ascending in the lift of princes and millionaires, I felt obliged by pure virtue to descend into the basement of gypsies. Exhausted, I was going to pay a visit to the little gypsy dancer, la Tchunga, who was about to dance for the Spanish refugees in Greenwich Village.

At that moment the flashbulbs of the photographers who wanted to snap us together struck me as terribly nauseating for the first time in my life, and I felt that the moment had come to swallow them and get rid of them viscerally. I asked a friend to take me back to the hotel. Still with the phosphenes of the fried eggs without a frying pan behind my closed, jaded eyes, I vomited copiously, and almost simultaneously I had the most abundant stool I ever produced in my life. This reminds me of that diplomatic and Buridanic problem which José Maria Sert once told me about someone who suffered from such bad breath and burped so fetidly that he found himself tactfully advised:

'It would have been better if you'd made that one a fart.'

I went to bed soaked in cold sweat like the dew of the alchemist, and one of the rarest and most intelligent smiles that Gala has ever seen appearing on my lips awakened in her gaze a question to which she was perhaps unable to guess the answer for the first time in our life. I told her:

'I have just experienced the simultaneous and very pleasant sensation of being strong enough to break banks, and yet in the process of losing a fortune.'

For without the scruples of Gala, whose purity has been patiently refined thousands of times over, and without her fierce habit of respecting agreed prices, I could easily and without fraud have greatly increased the already golden yield of my famous paranoiac-critical method. So it is once more the paroxysmal virtue of the alchemist's egg, as was believed in the Middle Ages, that makes possible the transmutation of the mind and of precious metals.

My doctor, Dr. Carballeiro, who immediately came to see me, explained that it was only what is called twenty-four-hour flu. I shall be able to leave for Europe tomorrow, when I have just enough fever to realise my most secret, most precious 'Clédanist'[3] dream, the dream I have been pursuing, without realising it, through all the irrational and imaginative events of the day, in order to achieve the triumph of my ascetism and of my complete and immaculate fidelity to Gala. I sent an emissary to my guests to explain that I could not join them and called the Champagne Room to make sure that they were royally treated (though with certain restrictions) and this is how my

3. Clédanism: a sexual perversion derived from the name of Solange de Cléda.

midnight Parsifal, without eggs and without frying pan, took place while Gala and Dalí slept the sleep of the just.

The next day, when I began my voyage back to Europe in the *United States*, I asked myself this: I should like to know who today is capable in a single day (a day contained from the outset in the space-time of the excremental egg of my early-morning dream) of successfully transmuting into precious creativity all the raw and shapeless time of my delirious material? Who, with the lightning stroke of a single egg, could have attached to his unique moustache the entire past and future history of Marxism? Who could have found the number 77,758,469,312, a magic figure capable of leading on to a viable path all abstract painting and modern art in general? Who could have succeeded in thrusting my biggest painting, *The Cosmic Dream Of Christopher Columbus*, into a marble museum three years before that museum was constructed? Who, I repeat, in one single afternoon, could have amassed, with Gala's erotic jasmines, so much perfect purity of whitest eggs, surpassing all that had been or was still to come, and mixed this with Dalí's most peccable ideas? Who, in fact, could live so much and agonise so much, abstain from eating so much and from vomiting so much and, from next to nothing, conjure up so much? Let anybody who can do better cast the first stone at me! Dalí is already kneeling to receive it full in the chest, because it can be none other than the philosopher's stone.

Now let us pass from the anecdote to the hierarchies of the category around the living nucleus of Gala, that soft motor which makes my paranoiac-critical method function, by turning into spiritual gold one of the most ammoniacal and demented days of my life in New York. You will see next how this same Galarinian nucleus operates when it is transposed to the supremely animist domain of the Homeric spaces of Port Lligat.

the 2nd

I dream about my two pitiable and almost translucid little baby teeth which I lost so late, and when I wake up I beg Gala to try and reconstruct, in the course of the day, the original effect of those two little teeth with the help of two grains of rice hung from the ceiling on a piece of thread. They will represent the primitive school of our Lilliputian *début*, which I want at all costs to have photographed by Robert Descharnes.

I shall do nothing all day, because that is what I am in the habit of doing during the six months a year that I live at Port Lligat. Nothing – which means that I paint without interruption. Gala is sitting on my naked feet like a space monkey or like a spring shower, or like a tiny basket garlanded with wild myrtle. In order not to waste my time, I ask her if she can draw me up a list of 'historical apples'. She recites it to me in the form of a litany:

'Apple of the original sin of Eve, anatomical Adam's apple, aesthetic apple of the judgment of Paris, William Tell's apple of the affections, Newton's apple of gravity, Cézanne's structural apple ...'

Then she laughingly says:

'No more historical apples, because the next one is the nuclear apple and that will explode.'

'Make it explode!' I tell her.

'It will explode at noon.'

I believe her, because everything she says is true. At noon, the short five-yard path at the side of our patio was lengthened by 300 yards because Gala had secretly bought the adjoining olive grove where, during the morning, a very white road had been marked out in chalk. The beginning of the road was marked by a pomegranate tree – and there in the form of a pomegranate was the explosive apple!

Next, Gala, anticipating my wishes, suggested inventing a box composed of six sides of virgin brass, which would receive the grapeshot consisting of nails and other cuneiform metals. With the explosion of the pomegranate in its centre, the box would engrave, instantaneously and apocalyptically, the six illustrations of my *Apocalypse According To Saint John*.[4]

'My heart, what do you want? My heart, what would you like?' This is how my mother talked to me each time she bent watchfully over me. To thank Gala for her explosive pomegranate I repeated to her:

'My heart, what do you want? My heart, what would you like?'

And she answered me with a new present:

'A heart made of rubies that beats!'

That heart has become the famous jewel of the Cheatham Collection, exhibited the world over.

My little space monkey has come to sit on my naked feet to rest from her role as *Leda Atomica*[5], which I was busy re-painting. My toes felt a gentle warmth that could come only from Jupiter, and I told her of my new fancy, which this time seemed to me impossible:

'Lay an egg for me!'

She laid two.

That evening on our patio – oh! Garcia Lorca's great wall of Spain! – I listened, intoxicated with jasmine, to the thesis of Dr. Roumeguère, according to which Gala and I incarnate the sublime myth of the Dioscuri, hatched from one of Leda's two divine eggs. At that moment, as if the egg of our two habitations was being 'shelled', I realised that Gala had arranged yet a third habitation for me, an enormous room, perfectly spherical and smooth, which is being built at the present time.

I am going to sleep like an egg filled with satisfaction. While thinking back on how, during the day, and without the need for my famous paranoiac-

4. Published by Joseph Foret, Paris, 1960, in a single edition.

5. Reference to the painting by Dalí (1954) 'entirely constructed in an invisible manner, according to the divine proportion of Lucas Paccioli'.

critical activity, I have received two new swans (which I forgot to mention), an explosive pomegranate, a heart of rubies that beats, the egg of my *Leda Atomica* of our own deification – and all with the sole purpose of protecting my work with the alchemical saliva of passion. But that was not all!

At half past ten, I am awakened out of my first sleep by a delegation from the mayor of Figueras, my birthplace, who wants to see me. It was written that the satisfaction contained in my egg would achieve a gigantic apotheosis. The giants that Gala, some years ago, had invented with Christian Dior for the Beistegui ball were to materialise that evening in the persons of Gala and myself. And, in fact, the Mayor's emissaries have come to inform me of their desire to incorporate in the Ampurdan mythology two processional giants in the form of effigies of Gala and myself. After this I shall at last be able to go to sleep for good. The two baby teeth of a dubious whiteness from my dream of this morning, which I wanted to have precariously suspended from a piece of thread, have transformed themselves on the threshold of the night's dream into the two authentic giants, of unchallengeable whiteness, that are Gala and Dalí. They walk steadily, their four feet on Gala's road, carrying very high the paintings of our gigantic works, while we prepare ourselves to go on with our pilgrimage in the world.

And if in our age of quasi-dwarfs, the colossal scandal of being a genius does not mean we are stoned like dogs or that we starve to death, it will only be by the grace of God.

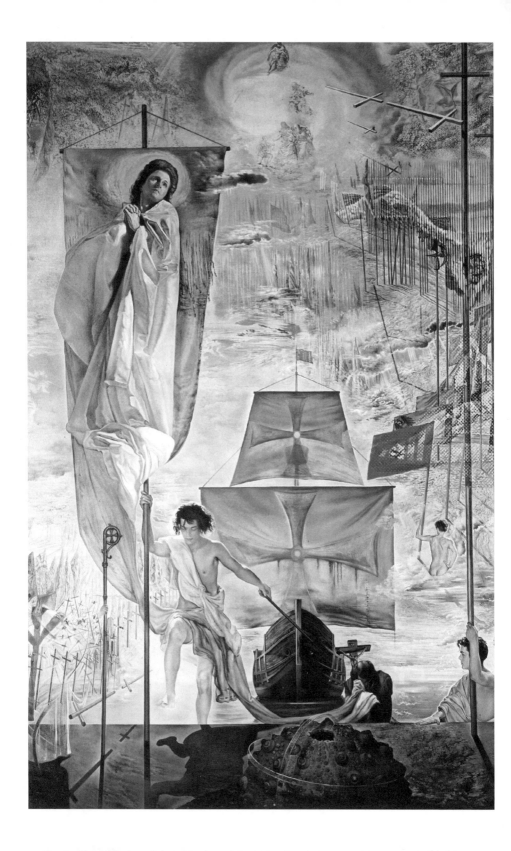

1959

No entries.[1]

1. On Dalí's door, in 1959, there is a notice in English and French: *'Prière de ne déranger.' 'Please do not disturb!'* Dalí paints, writes, meditates. Later he will divulge to us the secret of this year, one of the richest in his life.

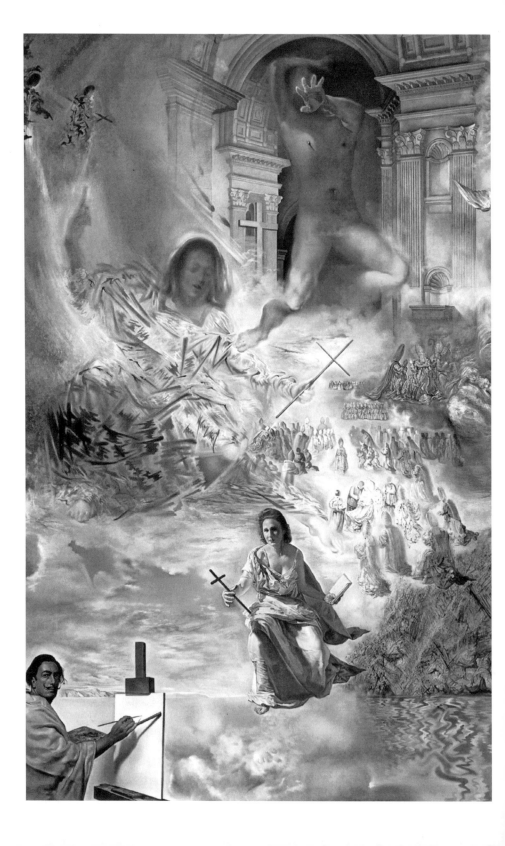

1960

May

Paris, the 19th

Surrounded by countless people who murmur my name and call me '*maître*', I am about to inaugurate the exhibition of my one hundred illustrations for the *Divine Comedy* at the Galliera Museum[1]. It is a very pleasant sensation, this admiration, as it flows over me in magic waves, again and again making nonsense of abstract art, which is dying of envy. When they ask me why I have depicted hell in bright colours, I answer that romanticism committed the ignominy of making us believe that hell was as black as the coal mines of Gustave Doré, where you cannot see a thing. All that is wrong. Dante's hell is illuminated by the sun and the honey of the Mediterranean, and that is why the terrors of my illustrations are analytical and supergelatinous with their coefficient of angelic viscosity.

The digestive hyper-aesthetics of two people devouring each other can for the first time be observed in my illustrations, and fully exposed to the light. It is a light that is frenzied with mystical and ammoniacal joy.

I wanted my illustrations for Dante to be like the faint signs of moisture in some divine cheese. This explains why they have the variegated aspect of butterfly wings.

Mysticism is cheese; Christ is cheese – or rather mountains of cheese! After all, does not Saint Augustine tell us that, in the Bible, Christ said: '*montanus coagulatus, montanus fermentatus*,' which should be taken to mean a veritable mountain of cheese! It is not Dalí who says this; it is Saint Augustine, and Dalí repeats it.

Ever since the divine beginnings of immortal Greece, the Greeks made out of the anguish of space and time, psychological gods and sublime, tragic

1. The exhibition at the Galliera Museum lasted from the 19th to the 31st of May, and attracted a considerable crowd. To mark the occasion a catalogue was published in honour of Dalí with the collaboration of Clovis Eyraud, René Héron de Villefosse, Marcel Brion, Bruno Froissart, Pierre Guégen, Claude Roger-Maix, J.-P. Crespelle, Jean Cathelin, Gaston Bonheur, André Parinaud, and Paul Carrière.

agitations of the human soul – the entire mythological anthropomorphism. Carrying on from the Greeks, Dalí is satisfied only when he is creating, out of the anguishes of space, time, and the quantified agitations of the soul, a cheese! And a mystical, divine cheese!

September

the 1st

Twenty years after I wrote the epilogue to my *Secret Life* my hair is still black, my feet have not yet known the degrading stigma of a single corn, and the incipient obesity of my belly has corrected itself after my appendicitis operation, resuming a shape close to what it was when I was an adolescent. While waiting for the faith that is the grace of God, I have become a hero. I made a mistake – two heroes! The hero, according to Freud, is a man who revolts against the paternal authority and the father, and finally vanquishes them. This was the case with my father, who loved me so much. But he was able to love me so little during his life that now, when he is in heaven, he is at the climax of another Cornelian tragedy: he can be happy only because his son has become a hero because of him. The situation is the same with Picasso, who is my second spiritual father. Though I have revolted against his authority and am occupied in vanquishing him in the same Cornelian manner, Picasso will be able to enjoy it during his lifetime. If one must be a hero it is better to be a hero twice over than not at all. Moreover, since my epilogue, I have not been divorced like everybody else but, on the contrary, I remarried my own wife, this time in the bosom of the Catholic Apostolic and Roman Church, as soon as the first poet of France,[2] who was Gala's first husband, made this possible for us by his death. My secret marriage took place in the Hermitage of the Virgin with the Angels, and I was overcome with a frenzy that exceeded all bounds because now I know there is no receptacle on earth capable of containing the precious elixirs of my unquenchable thirst for ceremonial, ritual, and the sacred.

Fifteen minutes after my remarriage, I was obsessed body and soul by a new fancy, a sort of violent toothache to remarry Gala yet again. Returning to Port Lligat at dusk, and looking out to sea as the tide was coming in, I met a bishop who was sitting down (it often happens, in my life, that I meet bishops who are sitting down at similar moments). I kissed his ring, but I kissed it with double gratitude after he had explained to me that I could remarry yet again according to the Coptic rite, one of the longest, most complicated, and exhausting that exist. He told me that this would add nothing to the Catholic sacrament, but that it would not take away anything from it either. That is for you, Dalí, Dioscuri! After having had so many fried eggs without frying pan, the only thing in life you still lack is a double nothing – nothing twice over – which would be nothing if it were not sacred.

2. Paul Eluard.

And to have that, at this point in my life, I had to invent a great Dalínian party. That party shall be given some day. But in the meantime, Georges Mathieu gives me his promise as a gentleman by writing:

'If in France the decadence of court parties begins with the Valois, who refuse access to the crowd, it grows worse under the Italian influence, which transforms these parties into spectacles with a mythological or allegorical significance whose only aim is to dazzle by magnificence and "good taste". The mundane parties of today, which are descended from these – whether they be given by Messrs. Arthur Lopez and Charles de Beistegui, by the Marquis de Cuevas or the Marquis d'Archangues – are nothing but archaeological "reconstructions".

'To live is primarily to participate. Since Dionysius the Areopagite, nobody in the West, neither Leonardo da Vinci nor Paracelsus, nor Goethe nor Nietzsche, has been in deeper communion with the cosmos than Dalí. To grant man access to the creative process, to nourish cosmic and social life – that is the role of the artist, and it is doubtless the greatest merit of the princes of the Italian Renaissance that they understood this obvious fact and entrusted the organisation of their festivities to da Vinci or to Brunelleschi.

'Endowed with the most prodigious imagination, with a taste for splendour, for theatre, for the grandiose, but also for games and for the sacred, Dalí disconcerts shallow minds because he hides truths by light, and because he uses the dialectic of analogy rather than that of identity. For those who take the trouble to discover the esoteric meaning of his movements, he appears as the most modest and the most fascinating magician, who carries lucidity to the point of knowing that he is more important as a cosmic genius than as a painter.'

I answered all these kind remarks with *The Pride Of The Ball Of Pride*, which contains my most general ideas on what a party should be today, and I did this in order to appease – prudently and well in advance – those of my friends whom I shall not invite.

The parties of our day will be lyrical apotheoses of the proud cybernetics, humiliated and deceived, because cybernetics alone will be able to accomplish the holy continuity of the living tradition of festivals. In fact, at the algid stage of the Renaissance, the party used to bring up to date the existential, quasi-instantaneous and paroxysmal pleasures of all the moral structures of information – snobberies, espionages, Machiavellian practices, liturgies, aesthetic deceptions, gastronomic Jesuitisms, feudal and Lilliputian disagreements, competitions between soft idiots...

Today only cybernetics, with the supreme potential of the theory of information, could instantaneously deceive on new statistical subjects all those attending the party and, in one fell swoop, all the snobs because, as Count Etienne de Beaumont said, 'Parties are given chiefly for those who are not

invited.'

The scatological dazzle of the sacred, which should be the culminating exclamation mark of any self-respecting party, will be, as in the past, expressed by the sacrificial rite of the archetype. As in Leonardo's time, when a dragon was disembowelled and from its wounds lilies bloomed, we must now proceed to smash the most highly developed, most complex, most expensive, most costly cybernetic machines. They will be sacrificed for the lofty pleasure and entertainment of princes only, in this way nullifying the social mission of these formidable machines which be their instantaneous and prodigious power to give information will have served only to afford an ephemeral and scarcely intellectual worldly orgasm to all those who have come to burn themselves at the icy flame of the deceiving diamond fire of the supra-cybernetic festivity.

Let us not forget that these orgies of information must be abundantly showered with the blood and noise of strong doses of operas of a concrete irrationality, and with the most concrete music and with abstract Mathieusian and Millarésian sets – like those already famous operas in which Dalí wants to have the volume of lyrical sound provoked by the castration-torture and the killing of 558 pigs against the sonorous background of 300 motor-cycles with their motors going, without of course forgetting such retrospective homages as those of interludes on organs filled with cats which are attached to the keyboards so that their angry mewings mingle with the divine music of Padre Vittoria which Philip II of Spain already practised in his time.

The new cybernetic festivities of useless information, which I have to restrain myself not to describe for the time being with the precision that is my glory, will spontaneously come about as soon as the traditional monarchies are restored, thus creating the Spanish unity of Europe.

The kings and princes and all the courtiers will go to enormous trouble to bring off these splendid festivities, while all the time very well aware that they do not give parties to amuse themselves but to try and feed the pride of their peoples.

Yet again I am faithful to my projects without the frying pan of my epilogue, in refusing obstinately to go to China or to undertake any journey to any Near or Far East. The two places that I do not want to stop seeing on each of my returns from New York – which happens mathematically and regularly once a year – are still the glorious doors of the Paris métro, viscous incarnation of all the spiritual nourishment of the New Era – Marx, Freud, Hitler, Proust, Picasso, Einstein, Max Planck, Gala, Dalí – and so many more; the other place is the very insignificant Perpignan station where, for reasons that are not yet very clear to me, Dalí's brain and soul have found the most sublime ideas. It is from some ideas stemming from Perpignan station that:

> While looking for the 'quantum of action'
> The painting itself, the painting it self, the
> paint ing it self is there.

While looking for the 'quantum of action'
How many experiments will he paint there
The painting itself, the painting it self, the
 paint ing itself is there.

I had to find in paint this 'quantum of action' which nowadays rules the microphysical structures of matter, and it could be found only through my capacity to provoke – supreme *provocateur* that I am – all the kinds of accidents that might escape the aesthetic and even animist scrutiny, in order to be able to communicate with the cosmos... The painting itself, the painting it self, the paint ing it self is there... The cosmos itself, the cosmos it self, the cos mos it is there. I started by the dispose-all ... the painting itself, the painting it self, the paint ing it self is there, the disposall itself, the disposale it self, the dis pos all it self is there. I expressed the mud and the substances of the inky octopuses from the bottom of the sea. With the living octopuses I would octopus. I have also made sea urchins paint, giving them a shot of adrenalin to convulse their agonies while sticking between the five teeth of their Aristotelian mouths, rods capable of transmitting their smallest oscillations on a surface covered with paraffin. I took advantage of a shower of little toads that fell from the sky during a thunderstorm so that they drew, by means of their own disruption, a toadish embroidery on a costume for Don Quixote. I mixed naked women, their bodies soaked with paint, thus converted into living rags, with freshly castrated pigs and with motor-cycles with their motors running, the whole enclosed in bags fit to receive never-before-seen maculations. I made live swans, stuffed with pomegranates, explode in order to register stroboscopically the least visceral laceration of their half-alive physiology.

One day I climbed up as fast as I could to the olive grove where I had carried out all these experiments, but I had brought neither my liquid machine gun nor the live rhinoceros that I would also have liked for the prints, nor even some half-dead octopus. It was the only time when – and this is something that did not happen to Louis XIV – 'I almost had to wait.' But Gala was there. She had just found a brush which she handed to me.

'Just try – perhaps with this!'

I tried. The miracle happened! All the experiments of twenty years came forth out of a few unique, archangelic brush strokes! All that throughout my life I had only suspected had just been realised. The 'quantum of action' of the painting itself ... of the painting it self ... of the paint ing it self is there ... resided in the nonchalant brush stroke of the heroism of Don Diego Velasquez de Silva, and while Dalí painted ... and the painting itself, and the painting it self, and the paint ing it self is there ... I heard Velasquez talking, and his brush said, as the paint flowed out: 'Have you hurt yourself, my child?' ... and the painting itself, and the painting it self, and the paint ing it self is there.

In the midst of anti-realist chaos, at the apogee of 'action painting', what strength Velasquez has! After three hundred years he appears as the only

great painter in history. Then Gala, with that proud modesty which only her countrymen are capable of conceding to the hero who succeeds said:

'Yes, but you have helped him a lot!'

I looked at her, but after that I did not need to look at her in order to know that, with her hair and my moustache, after the hairy hazel tree, the space monkey, and the basket garlanded with myrtle, she was going to look like a Velasquez under a spring shower, to whom I could make love.

Painting is the beloved image that comes in through the eyes and flows out by the brush point – and love is the same thing!

Chafarrinada, chafarrinada, chafarrinada, chafarrinada, chafarrinada – this was the new sperm out of which would be born all the future painters of the world, because the 'chafarrinadas' of Velasquez are oecumenical.

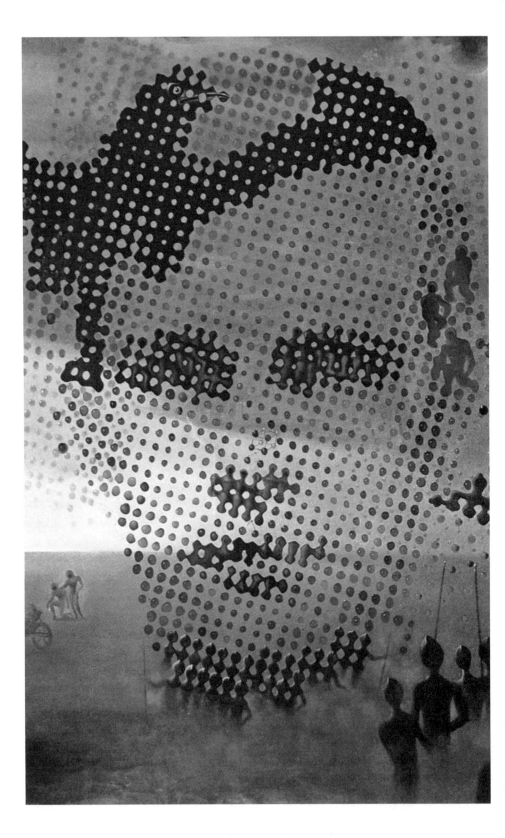

1961

No entries.[1]

1. The large ledger with the notarial aspect in which Dalí has written down his thoughts for 1961 bears in red capitals the words TOP SECRET. Later we too shall know what Dalí cogitated in Port Lligat and in New York. For the moment let us respect this discretion, normally so unlike him.

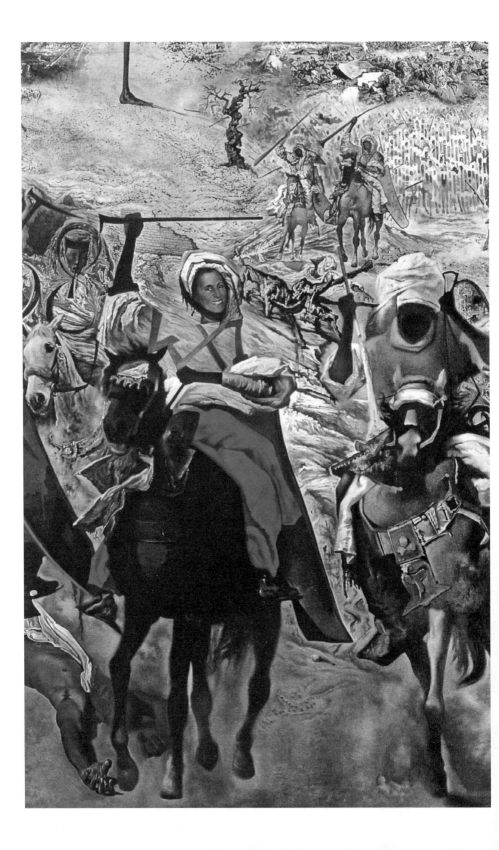

1962

November

Port Lligat, the 5th

The sixteen attributes of Raimondo Lulio are susceptible of 20,922,789,888 combinations. I woke up with the intention of reaching that number of combinations within my transparent sphere, in which for four days now I have been conducting the first experiments (the first as far as I know) on the 'flight of flies'. But the servants of the house are in an uproar: the sea is coming up very high. They say it is the biggest storm in thirty years. The electricity is cut off. It looks like the middle of the night, and we have to light candles. Gala's yellow boat has broken its mooring, and is floating around in the middle of the bay. Our sailor is crying and banging the table with his fist.

'I couldn't bear to see that boat go smashing against the rocks!' he cries.

I hear all this from my studio, where Gala comes to ask me to console the sailor whom the maids believe to have gone mad. But there! on my way down to him, I pass by the kitchen where in one snatch and with the speed and dexterity of an incredible hypocrisy, I catch in midflight the fly I needed for my experiment. Nobody has noticed it. To our sailor I say:

'Don't take it to heart! We'll buy another boat. Nobody could have foreseen such a storm!'

And with sudden playfulness I even go so far as to put my closed hand, with the fly in it, on his shoulder. Immediately he seems to calm down, and I go back to my studio to shut the fly inside the sphere. While I am watching the fly flying round, I hear loud shouts on the beach. I run down. Seventeen fishermen and the servants are crying, 'A miracle!' Just as the boat was about to smash against the rocks, the wind suddenly changed and it came to rest like a faithful and obedient animal on the sand pit in front of our house. With superhuman deftness, a sailor had thrown on board an anchor on the end of a slender cable, and they had managed to pull the boat away from the waves that were driving it on to the rocks broadside on. There is no need to point out that apart from the name Gala, my boat carries the name of *Milagros*, which means miracles.

Back in the studio, I find that my fly has also worked several miracles for its part, among the most extraordinary of which was the fact that it had realised the 20,922,789,888 combinations advocated by Raimondo Lulio which I had wanted so much when I awoke.

It was exactly eight minutes before noon.

Life must be dense with such occurrences which are mixtures of chance and the most thrilling dexterity! Which reminds me of my father, one morning in June, roaring like a lion:

'Come! Come at once! At once!'

We all arrived, greatly alarmed, to find my father pointing at a wax match that was standing up straight and burning on the slate tiles. Having lit his cigar he had thrown his match very high; after describing a wide arc which seemed to have extinguished it, it had landed vertically on the floor and had remained standing upright on the overheated tiles which had relit it. My father went on calling to the farmers who collected in a crowd:

'Come, come! You'll never see anything like this again!'

At the end of the meal, still under the tension of this phenomenon which had impressed me tremendously, I threw a cork into the air with all my might; after hitting the ceiling, it bounded off the top of the sideboard and finally came to rest, teetering on the end of a curtain rod. My father was overwhelmed by this second phenomenon. For an hour he contemplated the cork, forbidding anybody to move it from the spot where for several weeks our servants and friends were able to admire it.

the 6th

I spill coffee on my shirt. The first reaction of those who are not a genius like me – that is to say, the others – is to wipe it off. With me, it is just the opposite. Even in childhood, I had the habit of waiting for the moment when the maids and my parents could not see me so that I could quickly and furtively upset, between my shirt and my skin, the sticky remainder of my coffee. Apart from the ineffable voluptuousness of the liquid trickling down to my navel, its gradual drying and then the material sticking to my skin gave me an opportunity for steady periodic observations. Pulling slowly, gradually, or with jerks that I had awaited with long delight, I provoked new adhesions of the skin and the shirt which abounded in emotions and philosophical thoughts that lasted the whole day. This secret pleasure of my precocious intelligence reached its peak when, as an adolescent, hairs came to join in the stickiness at the centre of my chest (at the very spot where I located the potential of my religious faith), making a new complication out of the material of my shirt (a liturgical envelope). As a matter of fact, those few sticky hairs which stuck to the cloth, I now know to have been those which maintain the electronic contact thanks to which the ever-changing viscous element became the soft element of a truly mystical cybernetic machine which this very morning of the 6th of November I,

by the Grace of God, have invented by copiously spilling (and in an apparently involuntary manner), my coffee and cream which had too much sugar in it (of which I was unaware) – and all this in a most exciting way. It is a veritable crust of sugar that makes my finest shirt stick to the hairs on my chest, so full of my religious faith.

To summarise what I have said, it should be added that, being a genius, it is quite possible that given this simple accident (which for many would be no more than an insignificant annoyance), Dalí will manage to turn all its possibilities into a soft cybernetic machine that will enable me to reach, or rather to reach out towards, the faith that hitherto was merely a unique prerogative of the omnipotent grace of God.

the 7th

Of all the hyper-sybaritic pleasures of my life, perhaps one of the most intense and most stimulating (and even without the 'perhaps') is, and will continue to be, that of lying in the sun covered by flies. Thus I might say:

'Suffer little flies to come unto me!'

During breakfast at Port Lligat, I pour over my head the oil that is left from my plate of anchovies. At once the flies come buzzing down. If I dominate the situation by my thoughts, the tickling of the flies helps to accelerate them. On the other hand, that rarest of days when their presence bothers me is a sign that something is wrong and that the cybernetic mechanisms of my discoveries are grinding to a halt – to such an extent do I consider the flies to be the fairies of the Mediterranean. Even in antiquity they were in the habit of covering the faces of my illustrious predecessors, Socrates, Plato, or Homer[1] who, with closed eyes, described as sublime animals the famous cloud of flies buzzing around a pitcher of milk. I should like to remind readers here that I love only clean flies, flies dressed by Balenciaga, as I have already said, not those one encounters in offices or in middle-class apartments, but the ones that live on the leaves of olive trees, those that fly around a slightly decomposing sea urchin.

Today, the 7th of November, I read in a German book that Phidias drew his plan for a temple on the lines of a type of sea urchin which presented the most divine pentagonal structure he had ever seen. And it is today, the 7th of November, at two o'clock in the afternoon, while looking at five flies flying round a sea urchin's shell, that I have been able to observe that in each flight they make a spiral movement from right to left. If that law is confirmed, I have not the least doubt of its future: it will be as important for the cosmos as the law of Newton's famous apple, for I maintain that this fly everybody chases away contains within itself that quantum of action which God is forever putting

1. In May of 1957 Dalí had already discussed extensively the flies of Port Lligat, which he prefers to all other flies in the world.

under men's very noses to show them again and again the way of one of the universe's most hidden laws.

the 8th

Having gone to sleep with the thought that my life should really begin tomorrow or the day after – or the day after that – but soon (that, at least, is certain and ineluctable), this thought afforded me, a quarter of an hour before awakening, a creative dream theatricalised to its maximum scenic effect. As a matter of fact, my theatrical hour begins with a heavily gilded, brightly lit curtain having in its centre a small oddity so striking that it is noticed by the whole audience in an unforgettable way. When this outer curtain goes up, visions begin which immediately attain the pinnacle of the most grandiose tempestuous mythologies. A Jovian thunderbolt momentarily plunges everything into darkness. Everybody expects a fantastic heightening of effects, but – dramatic turn of events – the lights come on and once more illuminate the other curtain in exactly the same way as at the beginning. So the whole audience have been fooled with the exception of Dalí and Gala, who had had the same dream. People thought they were looking at the beginning of the opera of our life, but not at all... The curtain had not even gone up. That outer curtain, so cleverly used, is worth its weight in gold!

1963

September

the 3rd

I have always been in the habit of looking at the papers upside down. Instead of reading the news, I look at it and I see it. Even as an adolescent, I saw, among the typographical spirals, and just by squinting, soccer games as they would look on television. It even happened that before half time, I had to go and rest, so exhausted was I by the ups and downs of the game. Today, holding the papers upside down, I see divine things moving at such a pace that I decide, in a sublime inspiration of Dalínian pop art, to have pieces of newspapers repainted which contain aesthetic treasures that are often worthy of Phidias.

I shall have these newspapers, in outsize enlargements, quantified by fly droppings... This idea occurs to me when I notice the beauty of certain newspaper collages, yellowed and a bit flyspecked, by Pablo Picasso and Georges Braque.

This evening, while writing, I am listening to the radio, which is resounding with the boom of guns that are deservedly being fired for Braque's funeral. Braque – who is famous among other things for his aesthetic discovery of newspaper collages. And I dedicate in homage to him my most transcendent and much more instantaneously famous bust of Socrates quantified by flies.

the 19th

It is always at Perpignan station, when Gala is making arrangements for the paintings to follow us by train, that I have my most unique ideas. Even a few miles before this, at Boulou, my brain starts working; but it is the arrival at Perpignan station that marks an absolute mental ejaculation which then reaches its greatest and most sublime speculative height. I remain for a long time at this altitude, and you will note that during this ejaculation my eyes are always blank. Towards Lyon, however, the tension begins to slacken, and I arrive in Paris appeased by the gastronomic phantasies of the journey – Pic at Valence

and M. Dumaine at Saulieu. My brain becomes normal again though I am still a genius, as my readers should be so kind as to remember. Well, on this 19th of September, at Perpignan station, I had a kind of ecstasy that was cosmogonic and even stronger than preceding ones. I had an exact vision of the constitution of the universe. The universe, which is one of the most limited things that exist, is, all proportions being equal, similar in its structure to Perpignan railway station, with the sole difference to be found near the ticket office, where in the universe there is that enigmatic sculpture whose engraved reproduction had been intriguing me for several days. The empty part of the sculpture is quantified by nine flies from Boulou, and one single wine fly which is the anti-matter. Reader, look at my illustration and remember that all cosmogonies are born in this way.

Bonjour!

CHRONOLOGY 1950-65

1950

Paints *Dalí At The Age of Six When He Thought He Was A Young Girl Lifting Up The Skin Of The Sea To See A Dog Sleeping In The Shadow Of The Water*; and *Erotic Beach*. Begins writing his film script *Le Sang Catalan*.

1951

Paints *Christ of St. John Of The Cross*, now in Glasgow Art Museum. Also *Cupola Composed of Contorted Wheelbarrows* and *Raphaelesque Head Exploding*. Writes *Le Manifeste Mystique* (*Mystic Manifesto*; Paris: Editions Robert Godet). Photographic experiments with Philippe Halsman.

1952

Completes one hundred and two illustrations for Dante's *Divine Comedy*. Makes lecture tour of seven states of U.S., speaking on his "mystical nuclear" art. Paints *Galatea With Spheres*; *Assumpta Corpuscularia Lapislazulina*; *Nuclear Cross*; *Madonna In Particles*; and *The Angel Of Port Lligat*. Begins his painting *The Disintegration Of The Persistence Of Memory*. Begins to write a play, *Le Délire Erotique Mystique* (*Mystical Erotic Delirium*). Writes *The Divine Marquis' 120 Days Of Sodom In Reverse*, as a tribute to the Marquis de Sade. French edition of his autobiography published: *La Vie Secréte de Salvador Dalí* (Paris: La Table Ronde).

1953

Paints *The Grape Pickers: Bacchus' Chariot*, and designs sets for *The Grape Pickers' Ballet*.

1954

With Philippe Halsman, publishes *Dalí's Moustache* (New York: Simon & Schuster). Paints *Gala With Rhinocerontic Symptoms*; *Rhinocerontic Disintegration Of Illissus Of Phidias*; *Microphysical Madonna*; *Dalí Nude, Contemplating The Five Regular Bodies Metamorphized Into Corpuscles, In Which Suddenly Appear The Leda Of Leonardo Chromosomatized By The Visage Of Gala*; and *Corpus Hypercubicus*, now in the Metropolitan Museum of Art, New York. Great Dalí Retrospective in Rome (24 oils, 17 drawings, and the 102 watercolors illustrating *The Divine Comedy*). Begins a film with Robert Descharnes: *The Prodigious Adventure Of the Lace Maker And The Rhinoceros*. Paints *Two Adolescents* and *Young Virgin Auto-Sodomized By The Horns Of Her Own Chastity*. His essay *Mes Sécrets Cinématographiques* is published.

1955

The Sacrament Of The Last Supper exhibited at National Gallery, Washington, donated by Chester Dale. In this period of Vermeer, the rhinoceros, and the cauliflower, he paints *Paranoiac Copy Of Vermeer Of Delft's Lace Maker*. Dalí also lectures at the Sorbonne, and paints a portrait of actor Laurence Olivier as Hamlet.

1956

July 1-September 10: Great Dalí Retrospective at Knokkele-Zoute in Belgium (34 oils, 48 drawings, watercolors). Publishes a "treatise on modern art": *Les Cocus du Vieil Art Moderne* (*Cuckolds Of Old Modern Art*; Paris: Fasquelle). Paints *The Skull Of Zurbaran*; *Rhinocerontic Gooseflesh*; and *Still Life – Moving Fast*.

1957

Presentation of *Santiago el Grande,* now in Beaverbrook Art Gallery, Fredericton, New Brunswick (Canada). English translation of *Les Cocus du Vieil Art Moderne* appears as *Dalí On Modern Art* (New York: Dial; London: Vision Press; Haakon M. Chevalier, translator). Paintings include *The Celestial Ride* and *Modern Rhapsody – The Seven Arts*.

1958

St. James Of Compostela and *Sistine Madonna* are exhibited at Brussels World's Fair. At Orly Airport (Paris), Dalí creates a manger on the theme of Pope John XXIII's ear. Receives the Gold Medal of the City of Paris. Creates the Ovocipede. Draws Paris' Place des Vosges and Place de la Concorde. Paints *Velázquez Painting The Infanta Margarita With The Lights And Shadows Of His Own Glory*, and *Dionysus Spitting The Complete Image Of Cadaqués On The Tip Of The Tongue Of A Three-Storeyed Gaudínian Woman*.

1959

Finishes *The Discovery Of The New World By Christopher Columbus* (also known as *The Cosmic Dream Of Christopher Columbus)*, his first historical painting, exhibited in Huntington Hartford Collection at New York Gallery of Modern Art, then acquired by the A. Reynolds Morse Collection for the Salvador Dalí Museum, Cleveland (Beachwood), Ohio. Also paints *The Virgin Of Guadalupe*. Exhibits at the *EROS* exhibition in Paris.

1960

Draws *Coronation Of Pope John XXIII; The Angelic Crucifixion; The Ecumenical Council; Female Nude Seated; Birth Of A Deity*; and *Disciples At Emmaus*. Creates cover for *L'Apocalypse Selon Saint Jean* (*The Apocalypse According To St. John*), the world's most expensive book priced at $1 million. Films *Chaos And Creation* in New York.

1961

Sets and costumes for *Ballet de Gala* and one act of the Scarlatti opera, *The*

Spanish Lady And The Roman Cavalier, both produced in Venice. New expanded edition of *The Secret Life Of Salvador Dalí* (New York: Dial Press; London: Vision Press).

1962

Completes large painting, *The Battle Of Tetuan.* Also *The Sacred Heart Of Jesus*; *The Alchemist*; and *Saint George And The Dragon.*

1963

Paints *Galacidallahcidesoxyribonucleique* (a homage to Crick and Watson, New England Merchants National Bank, Boston). Completes *Portrait Of My Dead Brother* and *Death Of Raymond Lully.* Paints *Fifty Abstract Paintings Through Which At Three Meters' Distance One Can See Three Lenins Disguised As Chinese, All Forming The Maw Of A Royal Tiger,* and *Hercules Lifts The Skin Of The Sea And Stops Venus For An Instant From Waking Love.* Publishes *Le Mythe Tragique de l'Angélus de Millet* (*The Tragic Myth Of Millet's The Angelus*), with paranoiac-critical interpretation (Paris: Jean-Jacques Pauvert).

1964

Publication of *Journal d'un Génie* in Paris. Major Dalí retrospective in Tokyo. Paints *Landscape With Flies.*

1965

First English language edition of *Diary Of A Genius* (Doubleday, New York). Dalí films two *Screen Tests* with Andy Warhol. Major Dalí retrospective in New York. Creates two paintings entitled *Fantastic Voyage* to promote the film of that name. Paints *The Sun Of Dalí*; *The Railway Station At Perpignan*; and *The Apotheosis Of The Dollar.*

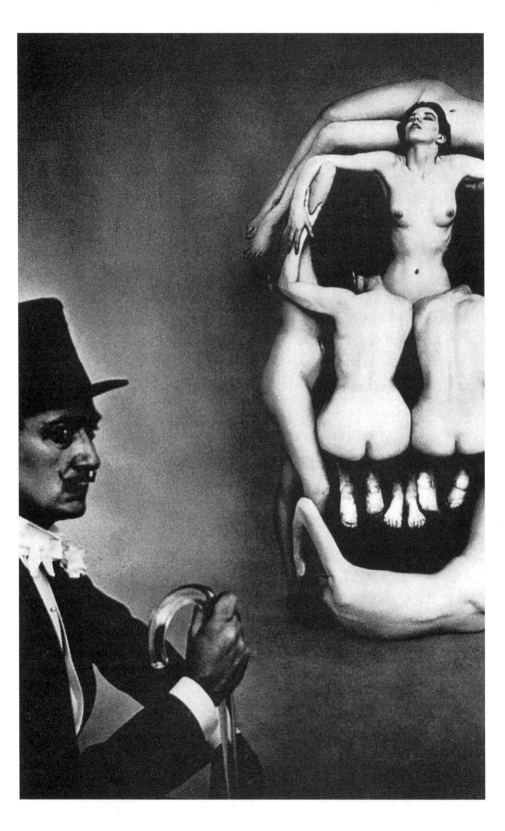

LIST OF ILLUSTRATIONS

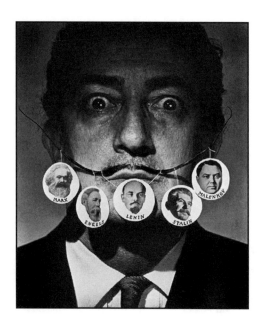

Salvador Dalí (1904–1989) entered the ranks of the Surrealists in 1929 with a series of iconoclastic paintings which fused technical virtuosity with Freudian infantilism, leading to his invention of the "paranoiac-critical" method. Later expelled from the Surrealist Group, he was christened "Avida Dollars" by André Breton whilst acquiring the reputation of master showman and scandalist. His art and writings remain amongst the most unique and important bodies of work of the 20th Century.

Photograph: Salvador Dalí, 1954; by Philippe Halsman.